MW00609875

IMAGES
of America

PORTLAND
FIREFIGHTING

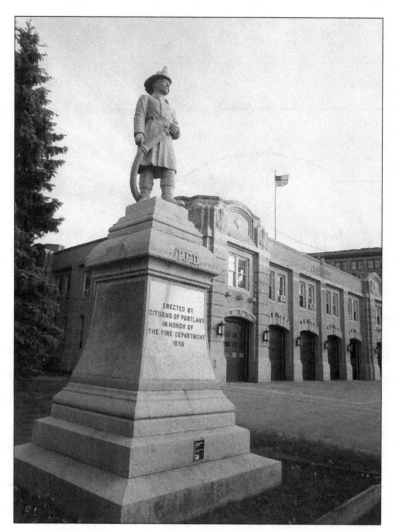

The Firemen's Monument sits on the property of Central Fire Station at the corner of Congress and Pearl Streets. The statue was erected on the Western Promenade at West Street in 1898. It was relocated in 1901 to the Portland Fire Department Relief Association lot in Evergreen Cemetery. It was again relocated in 1987, when Central reopened. The inscription reads "Erected by Citizens of Portland in Honor of the Fire Department 1898." (Authors' collection.)

On the Cover: The new Central Fire Station at 380 Congress Street is dedicated in 1925. From left to right are Ladder Five, Ladder One, Engine One, Chief Oliver Sanborn's car, Engine Five, and Chemical One. The crews are lined up along the ramp and on the apparatus in their Class A dress uniforms. (Courtesy of Portland Veteran Firemen's Association.)

IMAGES
of America

PORTLAND
FIREFIGHTING

Lt. Sean C. Donaghue and Andrea F. Donaghue
Foreword by Michael A. Daicy

ARCADIA
PUBLISHING

Copyright © 2018 by Lt. Sean C. Donaghue and Andrea F. Donaghue
ISBN 9781540228383

Published by Arcadia Publishing
Charleston, South Carolina

Library of Congress Control Number: 2017958416

For all general information, please contact Arcadia Publishing:
Telephone 843-853-2070
Fax 843-853-0044
E-mail sales@arcadiapublishing.com
For customer service and orders:
Toll-Free 1-888-313-2665

Visit us on the Internet at www.arcadiapublishing.com

*For the countless hours Portland Fire Department historian Michael
A. Daicy and thousands of Portland Fire Department members spent
creating and preserving the incredible history that is Portland firefighting.*

CONTENTS

FOREWORD

This book was produced to commemorate the 250 years the Portland Fire Department has been protecting and serving the city of Portland from fires and many other types of emergencies. Since 1768, there have been many improvements, reorganizations, changes, heroics, tragedies, and sacrifices.

Since the department's inception, thousands of fires have occurred, from small incipient fires to over 20 conflagrations. Four of these nearly destroyed the city, including a British attack during the Revolutionary War in 1775. The city's motto, *Resurgam* (I shall rise again), and the phoenix that rises from the ashes reflect its past.

As one of the oldest departments in America, we have evolved from bucket brigades, hand-drawn hand-pumping engines, hose and ladder carriages, horse-drawn steam fire engines, wagons, and ladder trucks to fireboats and motor apparatus and equipment; from elected fire wards and firemen to permanent fire chiefs and firefighters; and from protecting a small town on a peninsula to a thriving city of 21-plus square miles of neighborhoods, five inhabited islands, and over 68,000 citizens. The city has become a regional business center with a bustling waterfront, the busy Jetport, interstate highways, and rail service, and is an ever-increasing tourist destination.

Today's expectations, demands, and stress on public safety personnel across the country are ever heightened. These dedicated, educated, and well-trained men and women continue to give the city's citizens the very best service, compassion, and care. Though they are in harm's way, they love their calling.

The Portland Fire Department answered over 16,000 incidents and emergencies in 2017. These alarms and calls included fires, medical emergencies, vehicle accidents, hazardous conditions, public assistance, island emergencies, electrical hazards, airport and aircraft standbys, smoke and gas conditions, hazardous materials, alarm systems, waterfront emergencies, and many others.

With heartfelt appreciation, we say thank you to the city of Portland, its citizens, and businesses for supporting your fire department. They are truly first responders who arrive in two to five minutes and are on duty 24 hours a day every day to protect this great city.

It is with pride and honor that the Portland Fire Department's motto is inscribed on apparatus and vehicles: "Answering the bell, since 1768."

And the Portland Fire Department will continue to.

—Firefighter Michael A. Daicy, retired
Department Historian

ACKNOWLEDGMENTS

The inspiration to share the rich history of our department is the membership. This book is full of interesting things like stations and trucks, the things that make firefighting easier or more effective. These are the things admiring gazes are often drawn toward. But it has always been the members who make it possible and make it happen. The talent, determination, courage, and skill on display on any given day are truly remarkable. To the men and women of the Portland Fire Department, present and past, you are reason the book exists—it is a tribute to you.

This book would not be possible without the founding, existence, and support of the Portland Veteran Firemen's Association, which began preserving our history long before it was commonplace to do so. Unless otherwise noted, all photographs in the book have been collected and maintained by this extraordinary organization.

Mike Daicy, your immense contributions in time, effort, and knowledge are the foundation of all our work. It has been a truly humbling experience for us to gain insight into the extent of your dedication and the depth of your expertise.

To Chief David Jackson, thank you for your support of the 250th celebration, particularly this unique opportunity to share the photographic history of our fire department. Your pride in the Portland Fire Department and your administrative support of this project made it possible.

Thank you to Christopher Kelleher, Nick Oliver, and the Portland Museum of Art for your time and allowing us access to your beautiful facility.

We would like to extend our thanks to Brittany Buotte, Doug Dellefemine, and City of Portland Facilities Management for your assistance utilizing city hall for such a special project.

Thank you to Greater Portland Landmarks and the staff at the Portland Observatory for your enthusiasm and the opportunity to create one of our favorite parts of the book.

Special thanks to the Maine Historical Society for its support and contributions.

INTRODUCTION

In 1632, English settlers arrived on the eastern end of the peninsula that is now the site of Portland. They began building homes and referred to the area as Casco and the Neck in reference to the geographical lay of the land. The Native Americans called the area Machigonne (Great Neck).

In 1658, the area that is now Portland, Falmouth, Westbrook, Cape Elizabeth, and South Portland was named Falmouth after an English town on the river Fal. The peninsula area was referred to as Falmouth Neck. This large territory was the seventh town in the province of Maine, a part of Massachusetts, one of the original 13 colonies.

In 1676, Falmouth Neck was attacked during the First Indian War. Settlers were killed, and homes and crops were destroyed. Soon after, the inhabitants began rebuilding and resumed trading and shipping. A second, more severe attack occurred in 1690. In a period of five days, over 100 citizens were killed and all homes were burned after the surrender of Fort Loyal, which was at the foot of what is now India Street. The settlers' corpses were discovered two years later and were buried there by militia troops.

The settlement again started to rebuild, and shipping in the port at Falmouth Neck continued to flourish. More structures were being built, and the population grew to over 740 by 1753. Because of this, fire protection was a concern of the citizens.

On March 29, 1768, at a Falmouth town meeting, five fire wards were appointed for fire protection of Falmouth Neck. Their duty was to walk the streets after dusk checking for signs of fires. They had policing authority and would direct citizens to assist in fighting fires and forming bucket brigades. The emblem of the office was a red-painted six-foot pole (or stave) with a hook on the end, and the men carried a wooden rattle to use as a fire alarm. The fire wards were appointed annually. Local merchants and citizens raised money to purchase a fire engine to protect their businesses and properties.

At a town meeting on March 28, 1769, Article 12 was passed "To hear the request of Mr. Paul Little and others relating to those men that belong to the Engine and to vote the same as the Town sees cause." This was Portland's first engine company. At a May 22 meeting, it was voted to "excuse Paul Little and 16 Men from serving in any Town Office until March, 1775, in consideration of their taking care of and Managing the Engine." A small engine house was built on Middle Street, near the corner of King (India) Street, to house the engine.

On October 18, 1775, during the Revolutionary War, Falmouth Neck was bombarded by the English ship *Canceau* and four other vessels under command of Capt. Henry Mowat. Marines came ashore and torched the town, destroying 414 buildings, including the engine house and fire engine.

Shortly thereafter, citizens who had left the town during the bombardment began returning and rebuilding, and the seaport again began to flourish. The Falmouth Fire Society was formed in 1783. Members carried canvas bags and leather buckets to help save property from fires.

On July 4, 1786, Falmouth Neck became the town of Portland. The new town purchased its first fire engine in 1787, naming it *Neptune*, and built a small wooden engine house for it. A 15-man fire company was formed. A second engine, *Vigilant*, was purchased and arrived in 1794.

By 1800, the city's population grew to over 3,700, and a third engine was purchased from England in 1801. It arrived in early 1802, and was named *Cataract*. This larger barrel-shaped engine was painted green, but the company members soon repainted it vermilion red. Two Hunneman engines were purchased: *Extinguisher* in 1805 and a new *Neptune* in 1806. Another engine, *Portland*, was added in 1807, and as the population grew to over 7,000 by 1810, *Alert* was in service. Town records listed six engine companies in 1815.

Maine separated from Massachusetts to become America's 23rd state in 1820, and larger fires continued to occur in Portland. In 1822, over 20 structures burned on Green Street (Forest Avenue) off Maine (Congress) Street, and in 1826, two separate fires destroyed 20 to 30 structures in May and June. An axe company carrying hooks and ladders was established in 1827, along with two more engine companies with the arrival of engines *Deluge* and *Hydraulion* and a hose company. Also that year, a large brick two-story engine house was built at the corner of Market and Milk Streets, housing three engines and the hose company.

In 1830, another major fire struck in January. Soon after, a Boston-built Thayer engine named *Niagara* was purchased and a second hose company was organized. As the population grew to over 12,000, there were now nine engines, two hose companies, and an axe (ladder) company protecting the town.

Because of a lack of organization and independent control by the fire companies at fires, a committee was appointed by the town to petition the state legislature for an act to organize a fire department in Portland.

On February 19, 1831, Maine's governor signed an act establishing the Portland Fire Department (PFD). Nathaniel Mitchell was appointed chief engineer, along with four assistant engineers. The positions were appointed annually. Rules and regulations were adopted, giving them authority over the fire wards and fire companies. This organizational structure was a marked improvement over the old department. The fire companies were headed by a first director (captain), and fire company numbers were assigned. The growing town became the City of Portland in 1832.

In 1859, the PFD's first steam fire engine was purchased from the new Amoskeag Company in Manchester, New Hampshire. Holding serial No. 2, *Machigonne* Steam Fire Engine One went into service with a permanent "engineer" in October at the brick engine house on Congress Street, near the corner of Oak Street. Horses were assigned to haul the heavier steam engines and four-wheel hose carriages. The hand engine companies began to be disbanded as four more steam engines were purchased. By 1865, five steam engines were in service. One hand engine remained on Burnham Street in the far West End until 1881.

On July 4, 1866, a devastating conflagration destroyed over 1,500 buildings and a third of the city. Tents were sent from the US Army and set up on the lower part of Munjoy Hill for the 10,000 homeless citizens. This was the largest fire in America at the time, and it demanded the newly formed National Board of Fire Underwriters to act.

By March 1867, a new Gamewell fire alarm system was installed and a waterworks project was started to bring water from Sebago Lake to the city. Hydrants were installed and water was flowing into them by 1869.

In 1899, the city of Deering was annexed to Portland, and the PFD doubled in size. Chief Engineer Melville Eldridge was appointed the first permanent chief of the department, and began a reorganization, including eight additional Deering fire companies. Portland had grown to 21 square miles with a population of over 50,000 citizens for the PFD to protect.

Motorization began in 1915 under Chief Almus D. Butler. Other major changes were instituted by the new chief, Oliver T. Sanborn, in 1924. A new Central Fire Station opened that year. A motor repair division was created in 1925, and by 1929, the department was completely motorized and the last fire horses were retired. Also that year, a training division was established, with an annual drill school for all members.

Fires were increasing, including on the busy waterfront. The old wooden fireboat was replaced in 1931 with a new steel boat. By 1938, the PFD was staffed with all full-time firemen, except on the islands, manning 11 engine companies, including Peaks Engine 12, a squad company, and five ladder companies. The Fire Prevention Bureau was created in 1940, and during World War II, the Portland Civilian Defense Corps established 19 auxiliary fire units to assist the fire department. In 1942, the International Association of Firefighters Local 740, the Portland professional firefighters' union, was founded. By 1950, the National Board of Fire Underwriters assigned Portland the rare distinction of a Class A rating.

The 1960s and 1970s brought about equipment improvements, including air packs (self-contained breathing apparatus, or SCBAs), and the replacement and consolidation of firehouses under the administrations of Chiefs Carl P. Johnson, Joseph R. Cremo, Clement O. Dodd, and Joseph E. McDonough. The crash station opened in 1973 at the Portland International Jetport. Alarms and fires increased to record levels while staffing and on-duty strength reductions occurred, along with labor issues, which challenged the department during a nationwide arson era. A new civilian department of public safety was instituted by the city with the Medical Crisis Unit (Medcu), Peaks Island public safety officers, and airport security personnel. Central Fire Station was closed temporarily from 1979 to 1987.

By the mid-1980s, the fire department manned six engine companies, two ladder companies, two quint (combination) companies, the fireboat, and air rescue, each staffed with three or four on-duty firefighters. Fires were on the decline because of technology (smoke detectors, sprinklers, and alarm systems), while improved departmental training included hazardous materials preparedness, which was now a national concern. Also, Rescue One was reactivated.

The 1990s, under the administrations of Chiefs Carleton E. Winslow Jr. and Joseph E. Thomas Jr., saw new apparatus and the integration of Medcu into the fire department, with cross-training of paramedics as firefighters and firefighters upgrading with EMS training. Improved response to medical emergencies and fires continued into the 21st century under Chief Martin J. Jordan.

The terrorist attacks of September 11, 2001, brought a new perspective to the meaning of "first responders." Training improved, with a focus on personal safety awareness, hazmat, and weapons of mass destruction under the leadership of Chief Frederick J. LaMontagne Jr. During this time, emergency medical dispatching was instituted because of the increase in EMS calls and more ambulances being staffed.

In 2013, the department got a new look under the administration of a new chief, Jerome F. LaMoria. Several position changes were made, including three assistant chiefs, fire prevention, and the secretarial staff. Engine Company Four was decommissioned, and a fifth ambulance was activated.

Since 2016, under the leadership of Chief David J. Jackson, the department has continued to have highly trained, efficient, and dedicated members and staff. They continue to respond to over 16,000 alarms and emergencies of all types. They also continue to help and at times save their fellow citizens from fires and other emergencies. Doing the job in today's world can be quite difficult and challenging.

We congratulate the Portland Fire Department on its 250th anniversary. It continues today—24 hours a day, every day—to answer the bell to citizens and visitors, as it has done since March 29, 1768.

—Firefighter Michael A. Daicy, retired
Department Historian

One

HUMBLE BEGINNINGS

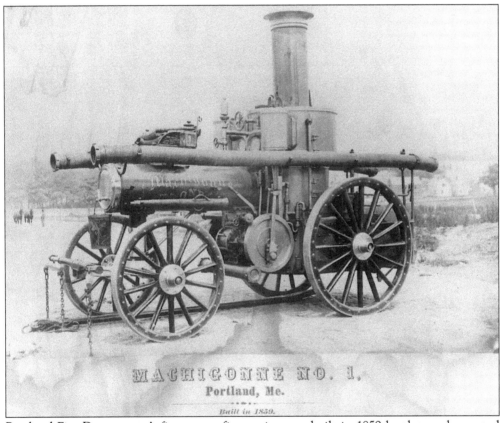

MACHIGONNE NO. 1,
Portland, Me.
Built in 1859.

Portland Fire Department's first steam fire engine was built in 1859 by the newly created Amoskeag Company of Manchester, New Hampshire. Given serial No. 2, this engine was the second ever produced by Amoskeag. The tradition at the time was to name fire apparatus after something of significance in the area. *Machigonne* was the Native American name for the greater Portland area.

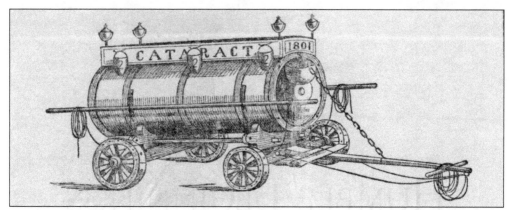

The fourth fire engine in Portland was built in 1801 in West Piccadilly, London, England, and arrived in February 1802. Upon its arrival, Cataract Company Two was created. The engine was originally painted green, but the color was disliked by so many that a council meeting was held, and it was voted to paint the apparatus a "bright, scarlet red." Engine Two served as a company from 1802 to 1964.

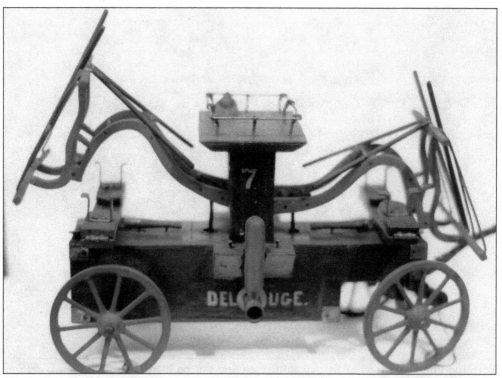

Here is a painstaking model recreation of Portland's 1827 *Deluge* Hand Engine Seven. Built by the company Merrick & Agnew in Philadelphia, the apparatus was a hand-pump, hand-drawn engine. Deluge Hand Engine Company Seven was organized in 1827 upon arrival of the apparatus and was disbanded in 1860.

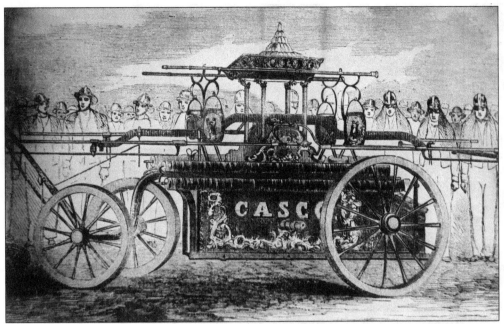

This undated drawing depicts *Casco* Engine One with members in uniform in the background. *Casco* was built by the Stephen Thayer Company in Boston in 1835. A student of Paul Revere, Thayer is widely credited with building the first fire engine in 1782, a hand-carried hand pump that required the use of buckets to fill it. Thayer officially operated his fire apparatus business from 1811 to 1861.

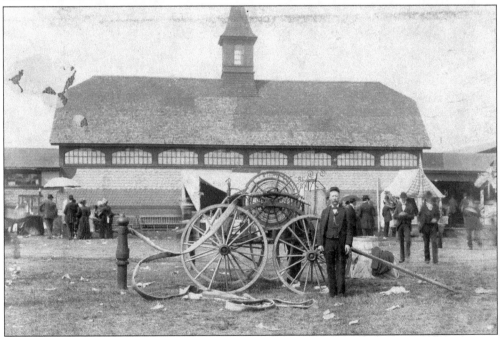

This 1845 hose carriage originally served the Portland Fire Department as *America* Hose Three from 1845 to 1846. It was sold in 1872 for a total of $175 to the City of Rochester, New Hampshire. The photograph is believed to be of the Rochester fairground, though the date is unknown.

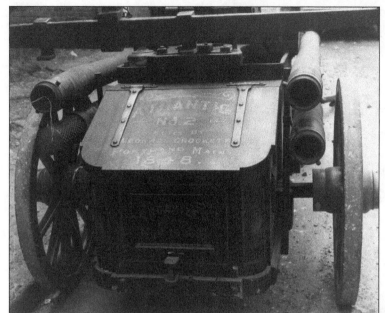

Atlantic Engine Two was delivered to the fire department on April 25, 1848. It was built by Leonard Crockett, who was based out of Portland, and cost a reported $1,000. It had a two-wheel hose carriage that ran with Hand Engine Two. It was put out of service in 1860.

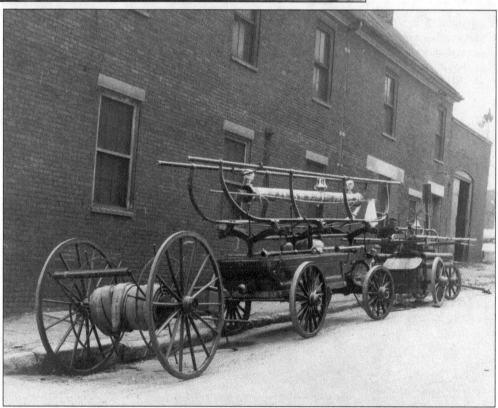

This undated photograph looking down the side of the Portland Veteran Firemen's Association building on Spring Street at the corner of South Street shows another view of *Atlantic* Two, in the rear. In the middle is the 1854 Jeffers hand engine that had been assigned to Peaks Island in 1884 and was named *Forest City*. A two-wheeled hose reel carriage is at left.

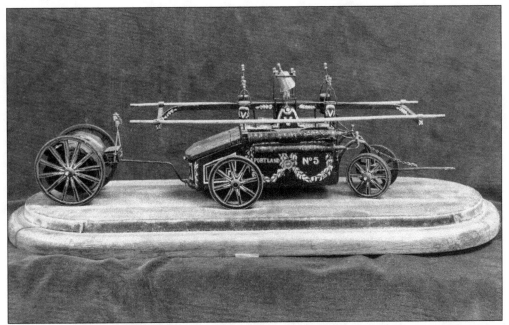

Portland Hand Engine Five was organized in 1837 and was originally the Thayer engine. This photograph shows a replica of the L. Crockett engine that replaced the Thayer on February 17, 1852. The engine was housed on the west side of Franklin Street, at the head of Summer Street (Courtesy of Maine Historical Society.)

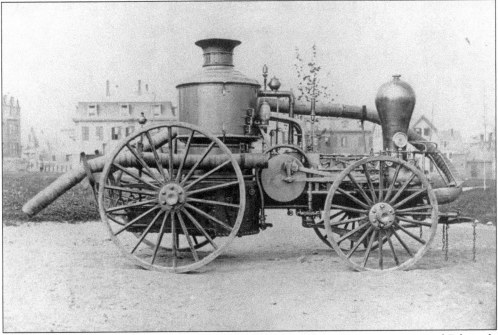

In March 1861, the second steam fire engine for the Portland Fire Department, named *Falmouth*, went into service. It was built by the Portland Company, weighed 8,755 pounds, and cost the city approximately $3,000. *Falmouth* was originally housed at 154 Congress Street, on the south side at the head of Smith Street.

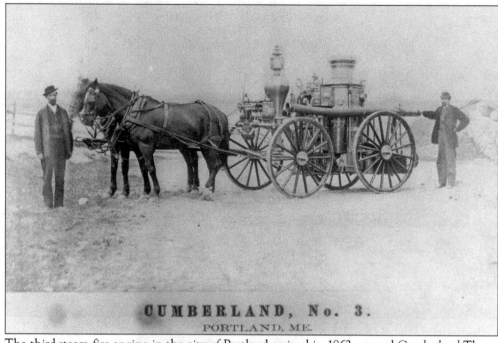

CUMBERLAND, No. 3.
PORTLAND, ME.

The third steam fire engine in the city of Portland arrived in 1862, named *Cumberland* Three. The Amoskeag second-class steam engine cost $2,750, was in service from 1862 until 1883, and was utilized during the 1866 conflagration. In 1870, it was reassigned to *Machigonne* One. The apparatus was rebuilt in 1871 and assigned as *Portland* Engine Two. In 1878, it was placed in reserve until it was traded in.

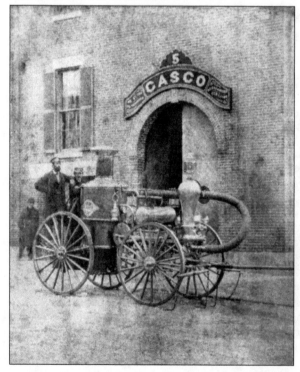

Casco Engine Five, shown in 1864, is a Portland Company second-size, 400-gallon-per-minute steam engine that cost $3,200. It was housed in the converted schoolhouse on Congress Street at the head of Smith Street. *Casco* Five was disabled at a fire in April 1866 and subsequently condemned, then stored in this firehouse. *Casco* Five and the engine house were both destroyed by the July 4, 1866, conflagration.

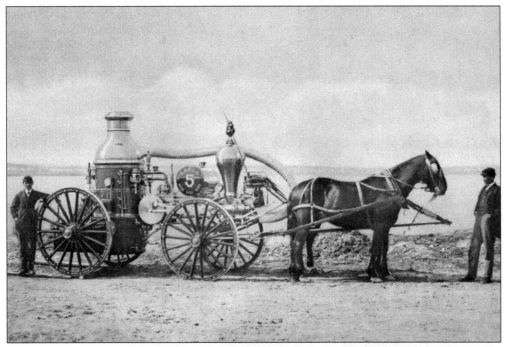

After losing both the apparatus and the firehouse in the conflagration of July 4, 1866, a new *Casco* Engine Five was built by the Portland Company. Stationed at the new engine house on the corner of Congress and Market Streets, it had a pumping rate of 400 gallons per minute and weighed 6,800 pounds. It was in service from September 14, 1866, until November 25, 1881. This photograph is from around 1868.

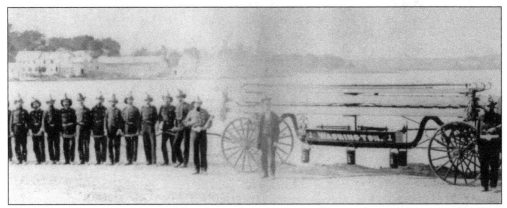

This 1868 photograph shows Ladder One, referred to as *Washington* One, and its crew. Portland began using this ladder and carriage, made by the Remington & Moulton company, in 1867. It was a replacement for the 1839 Ladder One carriage, which became a spare. Notice the buckets hanging from the bottom of the carriage.

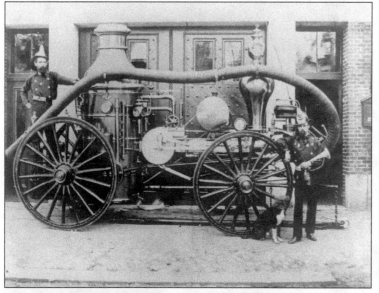

The second steam engine named *Cumberland* Three went into service on January 12, 1870. It was produced by the Portland Company for $3,250. It was a single pump tank with a 400 gallon-per-minute pump rate. Engine Three was housed at the 176 Brackett Street firehouse. This engine was taken out of service for good in June 1908.

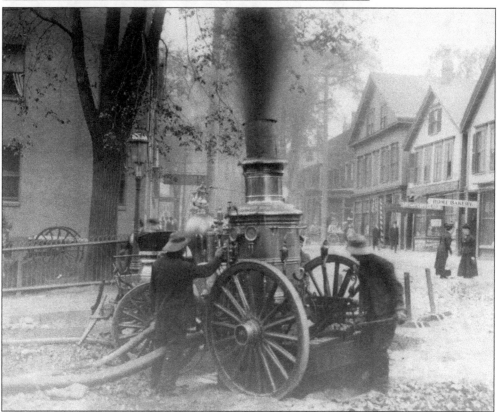

This undated photograph shows *Machigonne* One, the 1871 Amoskeag, at work on the corner of Free and Cotton Streets. The firefighter on the right, referred to as the stoker, is shoveling coal into the engine. The firefighter on the left adjusts the valves for the gauges. It is interesting to note that although these men are engaged in fighting a fire, everyday life continues around them as usual.

This scene looking up Maple Street from Commercial Street on July 28, 1902, shows two steam engines working at Box 61, a two-alarm fire at a manufacturing facility at 54 York Street. The engine in the foreground is known to be Steam Engine Two; its hose wagon sits next to it.

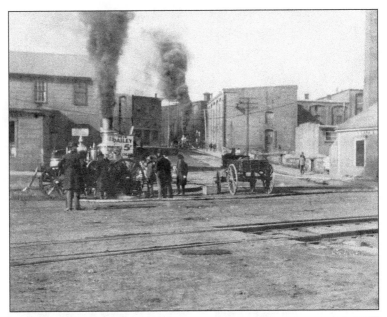

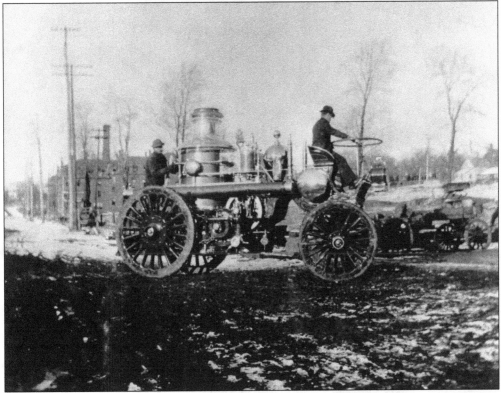

The only self-propelled steam engine in the PFD, a 1903 Amoskeag, was nicknamed "Old Rosie." The driver was responsible for steering, while the stoker, seen on the back of the engine, controlled braking. Old Rosie lacked a spark arrester and sent sparks into the air when responding to alarms. These sparks reportedly started a few awning fires, prompting awnings to be rolled up if the engine was passing by.

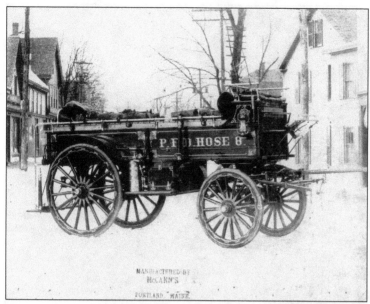

Engine Eight's hose wagon was a 1912 D.E. McCann two-horse hose wagon. McCann was a local company on Preble Street. The apparatus went into service on August 21, 1912, and was reassigned as Hose Three in 1916. It was taken out of service in 1920.

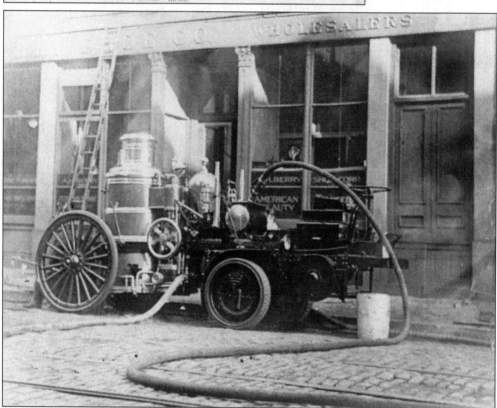

The last steam engine pump job for the Portland Fire Department is seen on August 17, 1929, the Emery Waterhouse fire. Steam Engine Three was the 1908 Amoskeag formerly known as Engine Four. As Engine Three, it was housed at 176 Brackett Street until 1929, when it was moved to Arbor Street. It remained in reserve at Central until 1945. This engine can be viewed at the Cole Museum in Bangor.

Two

FIREHOUSES

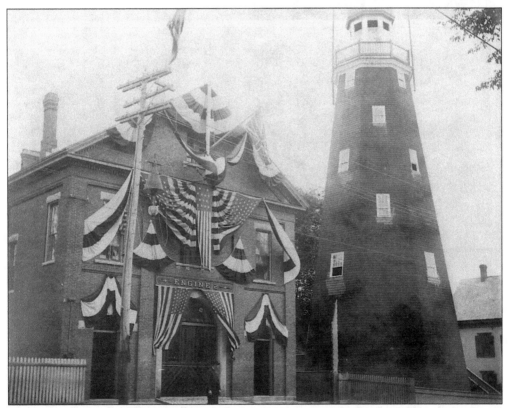

The original Munjoy Hill Fire House was built in 1864 next to the Portland Observatory. It was home to Engine Company Two from 1864 to 1964 and Engine Company One from 1964 to 1976. It was razed in 1976 to make way for a new combination community building and firehouse, which still stands today. This photograph is from the Fourth of July celebration of 1898.

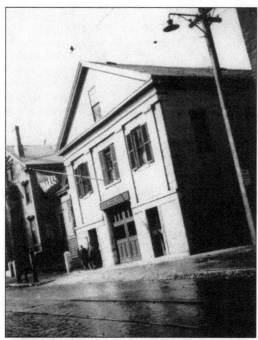

The Spring Street firehouse was constructed in 1837 to be used for multiple purposes. It was originally a schoolhouse, a meeting room for what was Ward Six, and the home to *Ocean* Engine Company Four. In 1868, the school portion relocated, and it remained an active firehouse until 1966. It is now home to the Portland Fire Department's own fire museum.

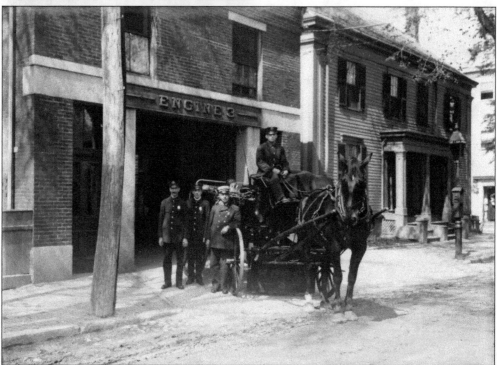

The first of the two separate Brackett Street firehouses was built in 1850, home to *Torrent* Hand Engine Six, later Hand Engine Four, and then Steam Engine Three in 1864. Steam Engine Three was motorized in 1925, then replaced in 1929 with a Seagrave motor pumper. The firehouse closed in 1947 when a new Mack quad truck was too long for the building. It was razed for the Reiche school property.

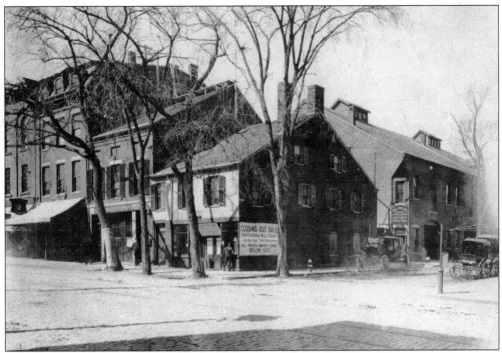

The firehouse at 555 Congress Street was built around 1850 and was originally home to *Casco* Hand Engine One. The Portland Fire Department's first steam engine, *Machigonne* Engine One, was assigned here in 1859, and the name is seen above the bay door. The station closed in 1918, but it is still standing and is recognizable today. This photograph is thought to have been taken around 1888.

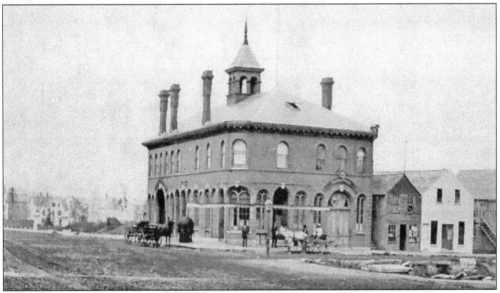

The building referred to as "Old Central" was built immediately following the great July Fourth conflagration of 1866. It was on the corner of Congress and Market Streets and was the quarters for multiple companies, including Engine Company Five, which is still stationed at Central today. Old Central was razed in 1924 after the opening of "New Central" on the same property.

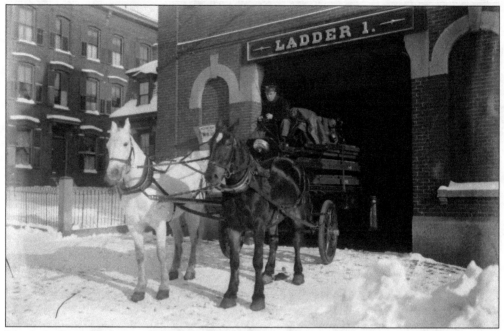

The India Street firehouse was built in 1869 and was used as a ward room for Ward Two. A spare hose carriage was kept here until Steam Engine Four moved in from 1873 to 1874. Starting in 1874, various companies were stationed here. In 1924, it closed to fire companies, though the motor repair shop remained here from 1953 to 1982. The building was sold in 1984 and still stands.

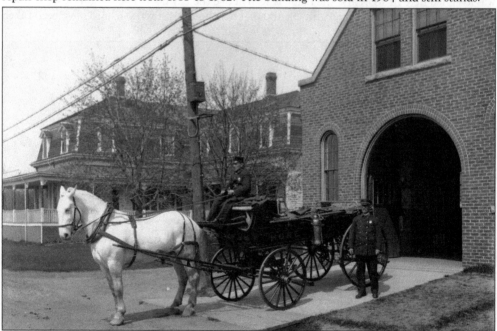

Though the firehouse on Peaks Island was built in 1884, firefighters were not permanently stationed here on a routine basis until 1910. In this photograph from May 1913, driver Abram Sterling and Capt. James C. Kent are ready to answer the bell. The station has since had several modifications and is now home to the PFD's Engine, Ladder, and Medcu 12.

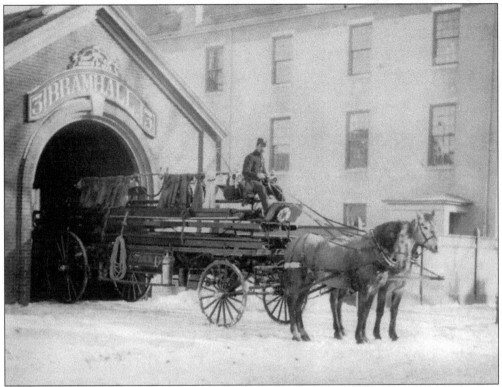

The second Brackett Street firehouse, at 163 Brackett Street, was built in 1883 across the street and down from the other Brackett Street firehouse. It was home to Ladder Company Three until the station closed in 1966 and the building was ultimately torn down.

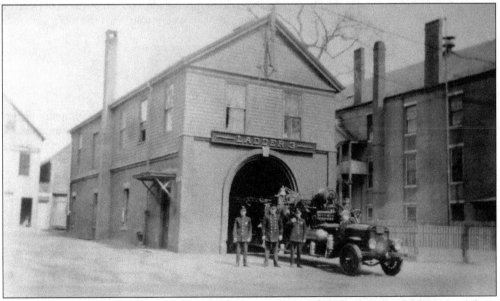

This c. 1925 photograph shows 163 Brackett Street as it looked after the addition of the second floor, which occurred in 1897. Also pictured is Ladder Three's first motorized truck, which was added in 1918. The building to the right of the firehouse is the same, the Brackett Street Schoolhouse.

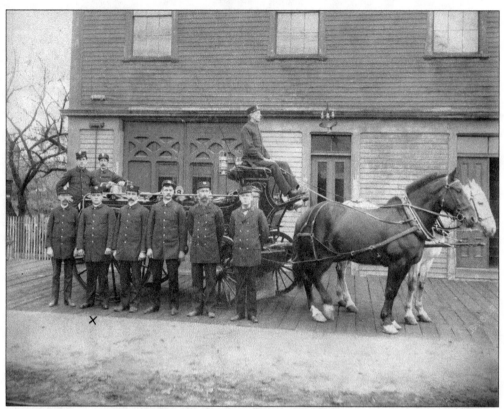

In 1900, Hose Company Eight and Ladder Company Four were quartered in the Woodfords area of Portland at 165 Woodford Street. This firehouse was the former quarters of the Deering Fire Department Hose One and Ladder One, which were renumbered after the annexation of Deering to Portland. The crew of Hose Eight is pictured in front of its quarters with the 1897 Talbot & Moulton wagon. The building still stands.

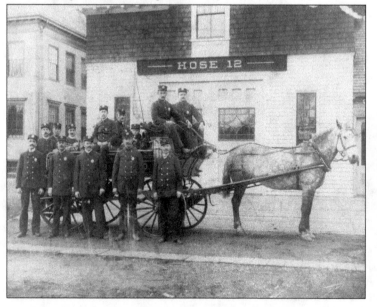

Hose Company 12 is seen at its firehouse on Pitt Street in the Oakdale section of Portland in 1900. Originally the quarters of Deering Fire Department Hose Company Eight, it was renumbered when it became part of the Portland Fire Department in 1899. The building was vacated in 1908 and later torn down.

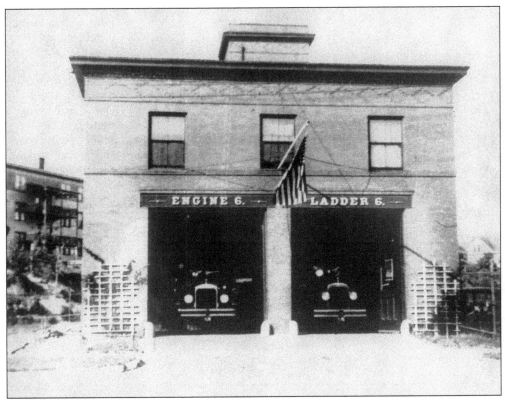

Opened in January 1903, the Park Avenue station was the quarters of Engine Company Six. Ladder Six was assigned here in 1924. A training tower was added in 1929. The motor repair shop was based here from 1929 to 1953. The station was closed in 1966 and sold in the 1990s. In this c. 1930 photograph, Engine Six and Ladder Six are seen in quarters. The building exists today.

The Arbor Street firehouse, located at Morrill's Corner, was built in 1902 but opened in January 1903. Originally, Steam Engine Company Nine was the only truck assigned here, but it was joined by Ladder Company Four in 1907. It closed in 1972 and was sold in the 1990s. The building still stands.

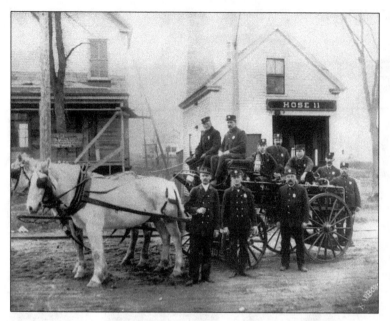

Built in 1895 by the members of Deering Hose Company Five, this station, at 550 Washington Avenue, housed Portland Hose Company 11 starting in 1899, when Deering was annexed to Portland. The station was closed in 1901 but has been used as a bakery for many years. Botto's Bakery is currently in the building. This picture was taken in 1900.

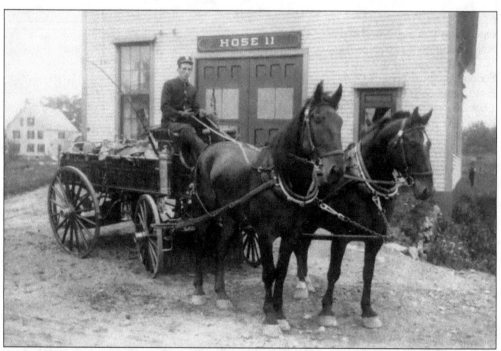

After the closing of the Washington Avenue firehouse, a converted barn at 246 Ocean Avenue was used by Hose 11 from 1901 to 1908 as a fire station. Seen in this 1902 picture, Hose 11 is an 1899 G.M. Stanwood wagon that was in service until 1925. The house in the background is on Washington Avenue and still exists today.

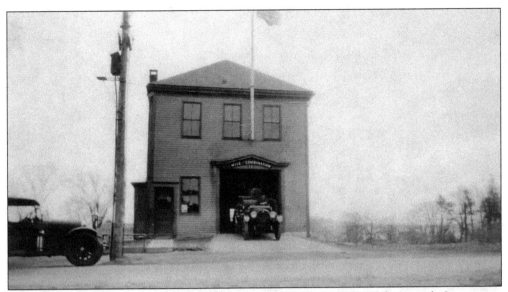

The 243 (later 479) Ocean Avenue firehouse can be seen in this c. 1925 photograph. It was open from 1908 to 1957 across from the current quarters of Engine 11. This building sat next to the Cummings Schoolhouse, which still stands today. The first motorized truck for Hose Company 11, the 1924 REO Combination Hose and Chemical, can be seen in the open bay door.

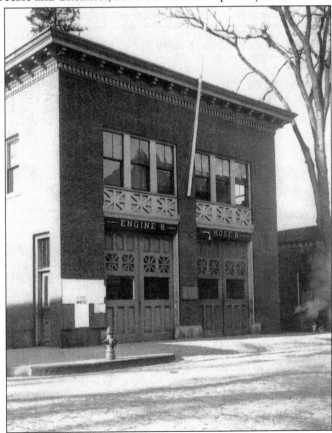

The 536 Deering Avenue firehouse, at Woodford's Corner at Revere Street, opened in June 1908. Beginning in 1910, the District Two chief was stationed here with Engine Company Eight, which included Hose Eight. They remained here until the station was closed down in 1967. The building is still in existence today.

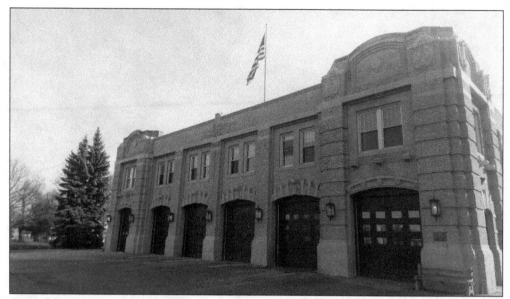

Central Fire Station, at 380 Congress Street, opened on November 10, 1924. The headquarters of the Portland Fire Department, Central at that time was home to the fire chief, the administrative staff, Engine Companies One and Five, Ladder Companies One and Five, and Chemical Company One. Today, Central is home to the chief, the administrative staff, Engine Company Five, Medcu Five, and Car Nine. (Authors' collection.)

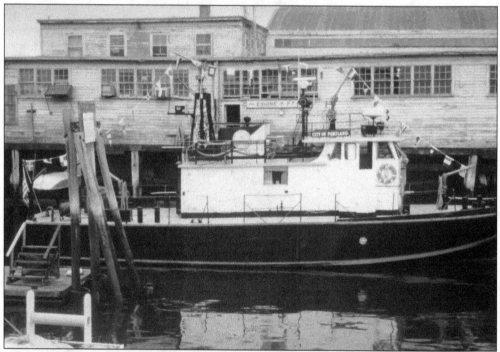

Engine Company Seven, or "the Fireboat" as it is commonly known, is seen at its home quarters on the west side of the State Pier. Engine Seven was originally stationed at the end of the Portland Pier. The quarters were moved to the State Pier in 1948. In 1985, the building was replaced with a new parking garage, with the fireboat quarters located inside.

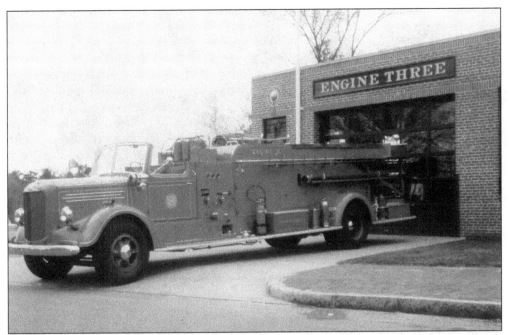

The Stevens Avenue firehouse was opened in 1951 and became the station of Engine Company Three, as seen in this 1956 photograph. It originally had only one truck bay with what was referred to as a "wide door." At that time, Engine Three was a 1947 Mack 750-gallon-per-minute pump quad truck. For many years, a tank truck was housed there with Engine Three as a double company.

After the construction of an additional truck bay, Ladder Company Three relocated with Engine Three from Engine 11 around 1972. In 1978, when this photograph was taken, Ladder Three was a 1961 Seagrave with a 100-foot aerial. Engine Three was a 1973 American LaFrance with a 1,000-gallon-per-minute pump. It continues to be an active fire station, home to Ladder Company Three and Medcu Three.

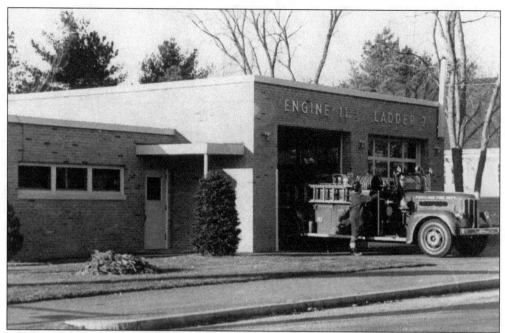

Pictured around 1962, this is the current quarters of Engine Company 11 at 580 Ocean Avenue. It was built in 1956 and opened in 1957. In the picture, Engine 11 is a 1953 Maxim. Generally, a spare piece of apparatus is stored here, currently an engine. Though Ladder Seven, a spare ladder truck at the time, was sold in 1961, the sign remained on the building until the 1990s.

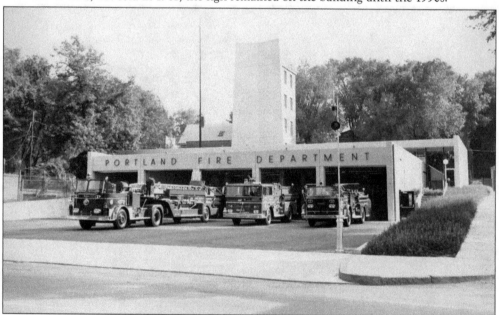

Bramhall Fire Station, located at 784 Congress Street, was opened in 1966 and doubled as a fallout shelter. Engine Companies Four and Six, Ladder Company Six, and the District One chief were all relocated here after its opening. Medcu Three was stationed here in 1975. Today, Bramhall houses Ladder Six, Engine Six, Rescue One, Medcu Six, and Car Two, the on-duty deputy chief in charge of daily operations.

Engine Eight and the District Two chief moved to the new Allen Avenue firehouse in 1967. Ladder Company Four was also here from 1972 to 1981. Engine Eight became a quint company in 1982 with a new American LaFrance 75-foot aerial. Medcu Five quartered here in 1990. In 2001, Engine Eight was renamed Ladder Company Four. Today, Ladder Four and Medcu Four are quartered here.

Located in the Riverton section of Portland at 1604 Forest Avenue is another firehouse that is still currently in use by the Portland Fire Department. Built in 1971 but opened on February 14, 1972, this station has always been home to Engine Company Nine. Ladder Five, the PFD's spare ladder, is also currently housed here as well.

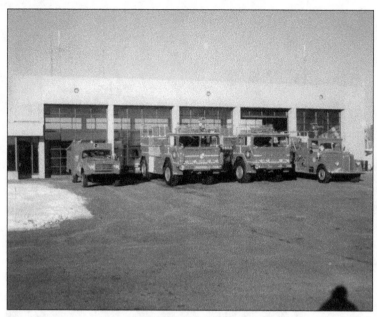

On April 17, 1973, the new PFD crash station opened at the Portland International Jetport. From left to right are Red Three, a 1975 International Quick Response vehicle; Red Two, a 1977 Walters CT-4 1500; Red One, a 1976 Walters CT-4 1500; and Red Four, a 1947 Mack 1,500-gallon foam tanker, the converted former Engine Three quad truck.

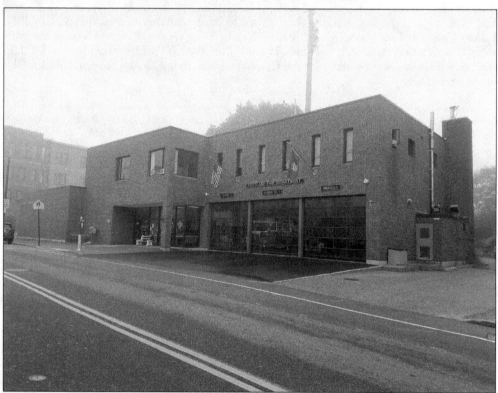

The new Munjoy Hill fire station opened in 1977 on the same lot as the 1864 firehouse. Engine One returned to the hill after temporarily running out of Central. The left side of the building also serves as a community center. Engine Five and Ladder One relocated here when Central closed in 1979. Engine Five returned to Central in 1987. Medcu One is now stationed here as well. (Authors' collection.)

Three

APPARATUS

Engine Five in 1903 was an Amoskeag double-extra first-size self-propeller horseless engine. This Engine Five was the only self-propelled engine ever in the PFD. The apparatus had a weight of 17,000 pounds, a cost of $9,000, and was the only apparatus to have the capability of pumping 1,350 gallons per minute. The truck was in service until 1924 and was placed in reserve until disposal in 1936.

Built by the Portland Company in 1865, *Portland* Steam Engine Two was a second-class 400-gallon-per-minute pumper that weighed 6,265 pounds and cost $4,500. Steam Engine Company Two was organized with the arrival of this pumper, and the new two-story brick firehouse was built to house it in 1864. This particular piece served Munjoy Hill until it was replaced in 1883 with a Silsby engine.

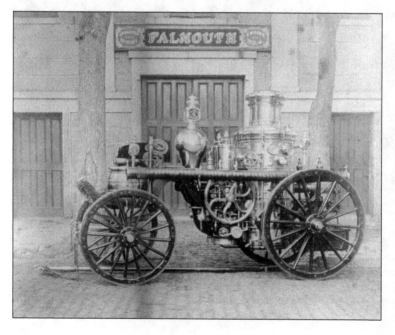

Falmouth Steam Engine Company Four was assigned a brand-new Amoskeag steam engine in 1873. It was first located at the India Street firehouse. It was relocated to 157 Spring Street in 1874, now the current site of the Portland Fire Museum. This photograph dates from around 1875.

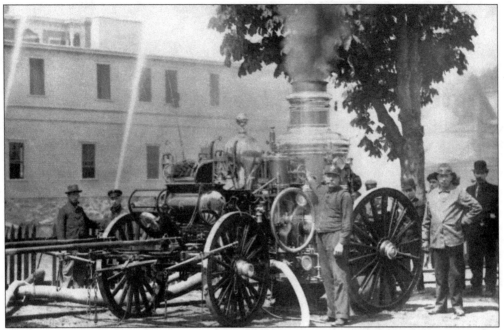

Engine Six, seen in this photograph, is the 1881 Amoskeag steam pumper originally assigned as *Casco* Engine Five from 1881 to 1903. Rebuilt in 1903, it was then reassigned as Engine Company Six's first steam engine. Housed at the new Park Avenue station with Hose Wagon Six, it significantly improved fire protection in Libbytown and the West End.

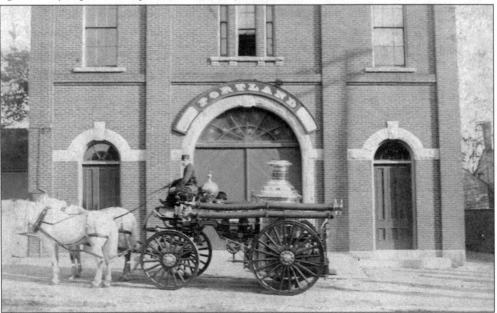

In 1883, a Silsby steam engine was assigned to Engine Company Two and stationed at the old Munjoy Hill firehouse, seen in this 1885 photograph. The front of the engine house was rebuilt to have three bays in 1899, when the new Ladder Two was assigned. The Silsby Steam Engine Two was completely rebuilt by Amoskeag in 1906 and assigned Amoskeag serial No. 788 due to the extent of the work.

In 1912, Engine Company Five was still running with the 17,000-pound, self-propelled 1903 Amoskeag double-extra first-sized steam engine. The apparatus was housed in the old Central Fire Station. Seen behind Engine Five is a spare engine, which was a horse-drawn 1908 Amoskeag. Close inspection of the tank underneath the driver's seat shows the reflection of the line of apparatus housed at Central at the time.

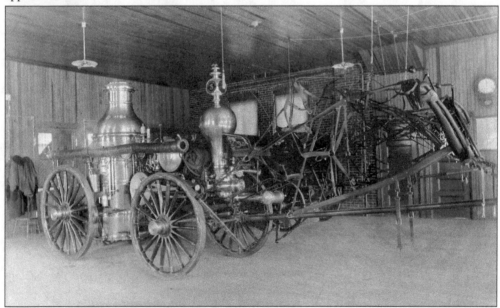

Steam Engine Nine, with Hose Wagon Nine in the background, is seen in 1903 inside the just-completed Arbor Street fire station. This steam engine was built by the Portland Company in 1870 and years later was referred to as the "Moxie Bottle." It had originally been assigned to *Cumberland* Engine Three. Notice the horse stalls behind the apparatus.

In 1909, Hose Company 11 became a double company with a combination ladder and chemical truck to run with the hose wagon. Combination 11 is seen in the 1908 Ocean Avenue firehouse next to the Cummings School, across from the current quarters of Engine 11. Permanent staffing increased from one to four with the arrival of Combination 11. The double company ended in 1925 with the arrival of a motorized truck.

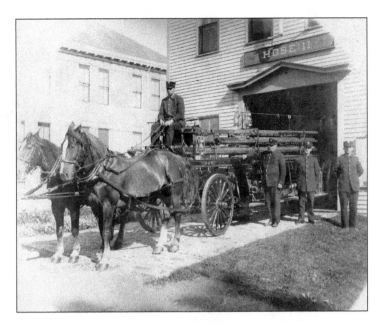

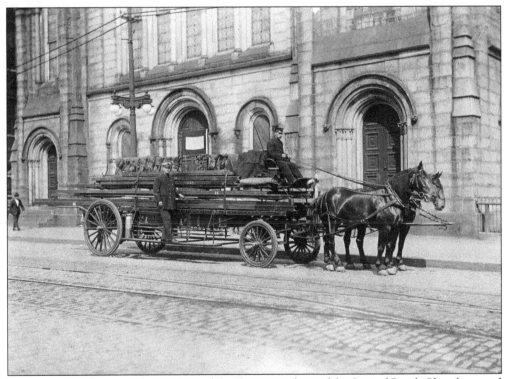

Ladder One can be seen opposite Central Fire Station in front of the Second Parish Church around 1913. The truck was built by Talbot & Moulton, and its construction dates to 1885. Notice the trolley tracks on the cobblestoned Congress Street in the foreground. Portland was the first city in Maine to have horse-drawn trolleys, starting in 1863.

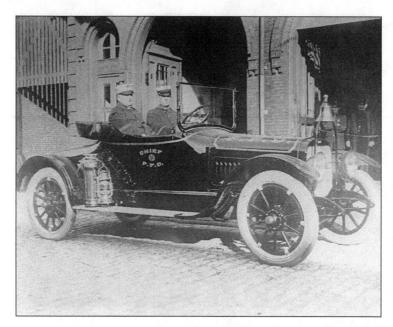

In 1915, motorization of the Portland Fire Department began with the purchase of a new Chandler Roadster for Chief Almus D. Butler, shown here with his driver, Lt. Albion Moulton, in front of the old Central Fire Station on Congress Street. The automobile replaced the chief's horse-drawn carriage.

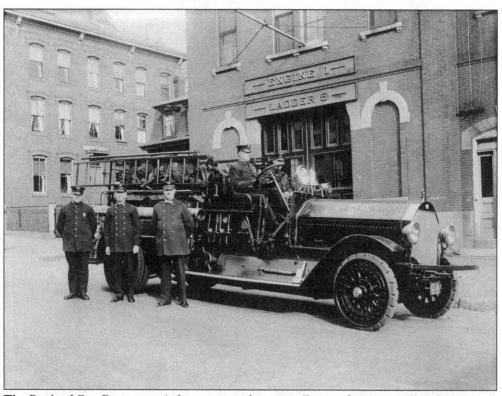

The Portland Fire Department's first motorized pumper, Engine One, was a 1917 Seagrave. It pumped 1,000 gallons per minute and was originally stationed at the 555 Congress Street station. It was reassigned to the India Street firehouse with Ladder Five from 1918 to 1925. The officer standing at the right is Capt. Melville Frank. This photograph dates from around 1920.

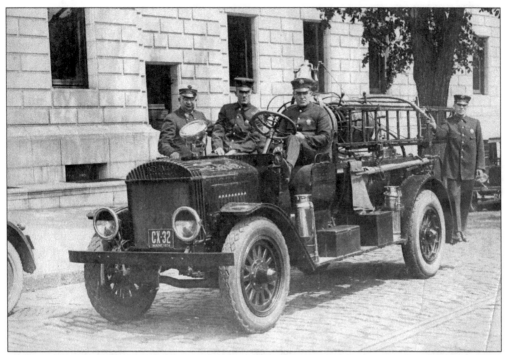

Chemical Company One's first motorized unit was a 1918 REO. Its chemical tanks were repurposed from the old horse-drawn 1892 unit. The firemen in this 1924 photograph are, from left to right, Lt. William Berry, Pvt. Leslie McVane, driver Pvt. Frank Mullins, and Pvt. Arthur Murdock. "The Chemical," as it was known, ran on every bell alarm on the peninsula.

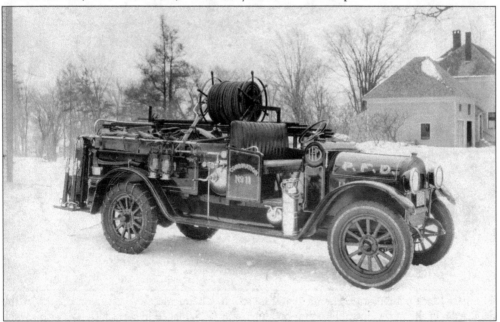

Hose 11's first motorized apparatus was a 1924 REO. Shown in this undated photograph, the truck had been rebuilt in 1925 as a chemical and hose combination. The chemical tank can be seen behind the seat, and the chains on the rear tires were a necessity for tough winters in Maine.

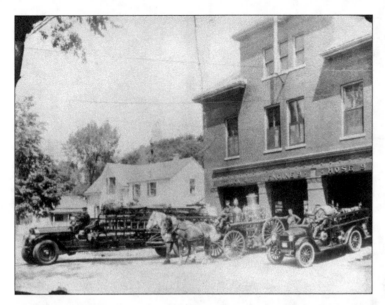

Ladder Four, Steam Engine Nine, and Hose Nine are shown at the Arbor Street firehouse in 1925. Note the transition from horse-drawn to motorized apparatus, as Engine Nine is a 1908 third-size steam engine, while Hose Nine and Ladder Four are both motorized apparatus. Ladder Four is a 1922 American LaFrance City Service ladder truck, and Hose Nine is a 1921 REO Hose and Chemical.

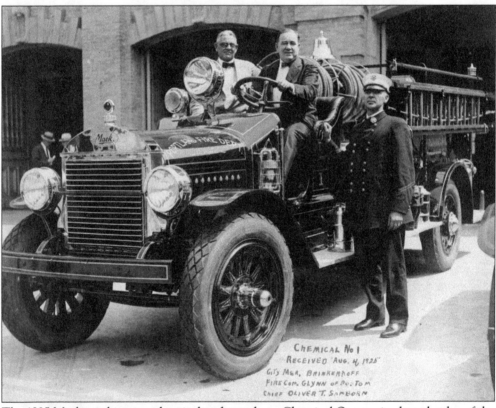

The 1925 Mack combination chemical and squad car, Chemical One, arrived on the day of the dedication of the new Central Fire Station, August 4, 1925. Placed in service that day, the Mack had three 40-gallon tanks, 500 feet of chemical hose, and 45 feet of ladders. From left to right are Portland city manager Harry Brinkerhoff, Boston fire commissioner Theodore A. Glynn, and Portland Fire Department chief Oliver T. Sanborn.

The 1927 Park Avenue firehouse consisted of Engine Six and Ladder Six, which were a combined company until 1930. The first motorized apparatus for Engine Company Six was the former 1916 American LaFrance Hose Eight, one of the Portland Fire Department's first motorized apparatus. A 350-gallon-per-minute pump was added to the combination truck in 1926. Ladder Six consisted of driver H. Noyes and horses Fred and Joe.

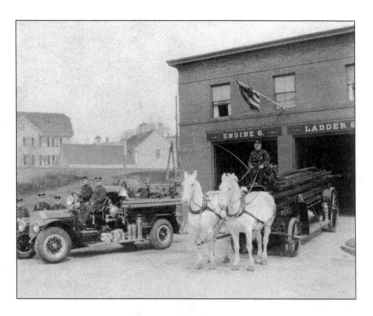

The 1920 Seagrave 750-gallon-per-minute pumper, formerly Engine Four, was reassigned to Engine Company Three in 1929, as seen in this photograph. It replaced the motorized Steam Engine Three as well as Hose Wagon Three, drawn by the PFD's last two fire horses, Dan and Pete. Quickly purchased by former governor Percival Baxter, an honorary Portland Veteran Firemen's Association member and animal lover, Dan and Pete retired from the PFD to Baxter Island.

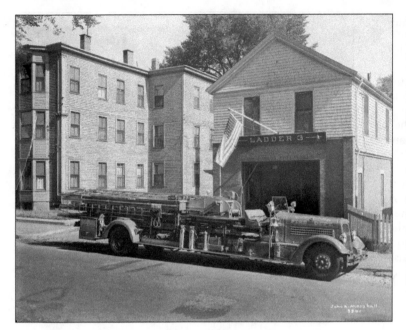

This 1936 Seagrave Ladder Three, sitting in front of the 163 Brackett Street firehouse, had the PFD's first steel aerial ladder, which was 65 feet in length. The truck was replaced in 1957 with Ladder One's former 1944 Seagrave 65-foot aerial. The 1936 Seagrave became a spare truck, housed at Engine 11 as Ladder Seven.

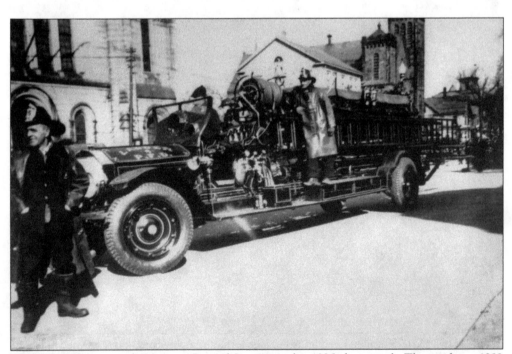

Ladder Four is seen on the ramp at Central Station in this 1936 photograph. The truck is a 1922 American LaFrance City Service ladder truck, the first motorized apparatus for Ladder Company Four. It was replaced in 1945 with a 65-foot Seagrave steel aerial ladder truck, a twin truck to Ladder One.

44

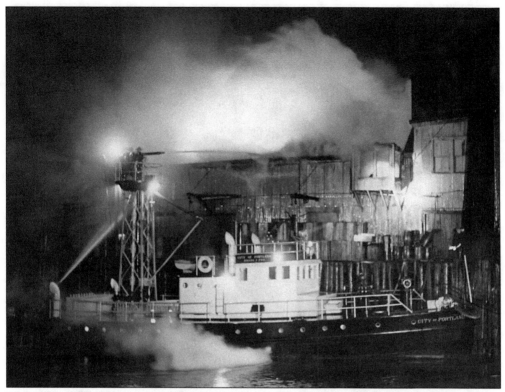

In this December 1936 picture, Engine Seven is operating at the Portland Fish Pier Fire. This is the second fireboat designated Engine Seven, built in 1931 by the General Ship Company. The boat was a 90-foot steel vessel with a pumping capacity of 6,000 gallons per minute from four monitors. The boat was in service until it was replaced in 1959.

The Engine Five crew is pictured in full gear at Central Fire Station on its 1937 Seagrave, the department's first 1,250-gallon-per-minute pumper. In the background, Portland City Hall and the Masonic Building can be seen on the opposite side of Congress Street.

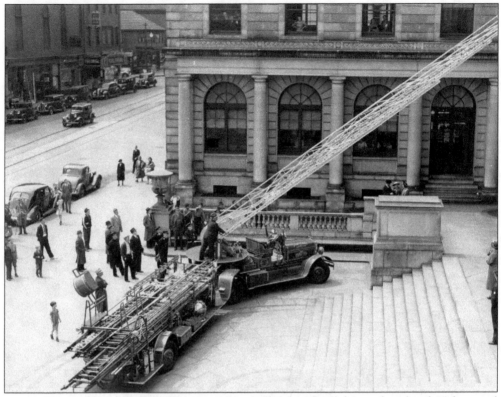

In May 1938, a demonstration was given at city hall showing off the newly refitted 85-foot steel aerial on the 1929 Seagrave of Ladder Six, replacing the 75-foot wooden aerial. Notice the people looking out of the second-floor windows of city hall from what is now the State of Maine Room. In the upper left corner, the former Colonial Theatre is visible.

The first Rescue One is seen in 1946. The truck is a 1943 Chevrolet commissioned upon organization of the company in 1943 with the mission of carrying specialty tools and lighting in addition to firefighting. Though substantially larger, today's Rescue One continues the original mission, carrying specialized equipment to support vehicle extrication, rope rescue, water rescue, hazmat, and more.

April 1947 finds Ladder Five on the ramp of Central Fire Station, opposite the Second Parish Congregational Church. Tillerman Everett Swasey is at the tiller seat of the 1928 Seagrave 75-foot wooden aerial, originally from Ladder Six's 1929 Seagrave trailer. The 1928 trailer originally had an 85-foot wooden aerial, removed after an accident on an icy Anderson Street damaged it on December 27, 1937. The tractor is a 1922 Seagrave.

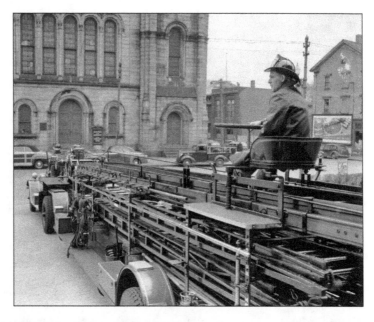

Lt. J.L. MacVane stands inside the Peaks Island Firehouse on February 1, 1948, with Engine 12 and Hose 12. On the left, Engine 12 is a 1938 McCann/Diamond T with a 500-gallon-per-minute pump. Hose 12 is a 1921 REO Hose and Chemical combination, the Peaks station's first motorized truck. The McCann replaced the REO to upgrade Peaks Island to an engine company.

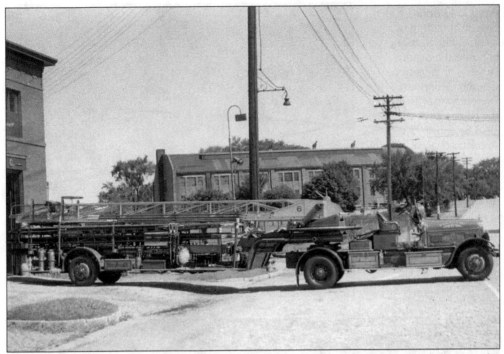

Ladder Six is seen in 1953 at the firehouse on Park Avenue, with the Portland Expo in the background. The truck at the time was still the 1929 Seagrave that had been refitted in 1938 with the 85-foot steel aerial, replacing the former 75-foot wooden aerial. This was Ladder Six's first steel aerial.

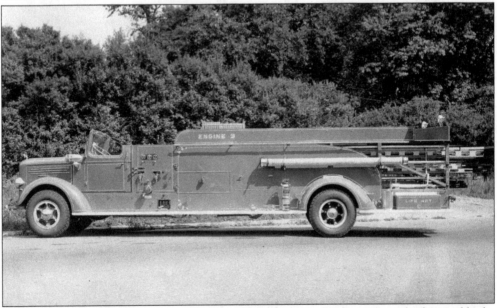

This 1954 photograph shows Engine Three, a 1947 Mack quad. A unique truck, the quad had a pump, hose, water, and a complement of ground ladders. This truck was too large for the Brackett Street engine house and was relocated to Central for four years before moving to the new Stevens Avenue firehouse in Rosemont in 1951.

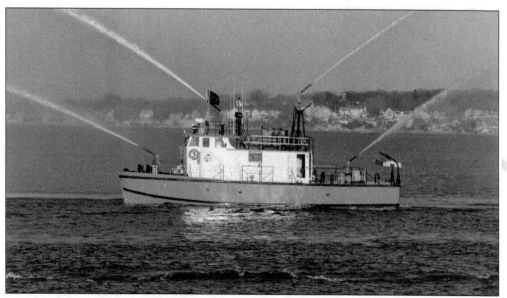

In the 123 years that Portland has had fireboats in service, there have only been four boats designated Engine Seven. The third Engine Seven, a 65-foot steel hull with four monitors and 7,000-gallon-per-minute capacity, was the longest-serving by far. This fireboat was in service from 1959 until 2009. This photograph of the third Engine Seven is dated 1995.

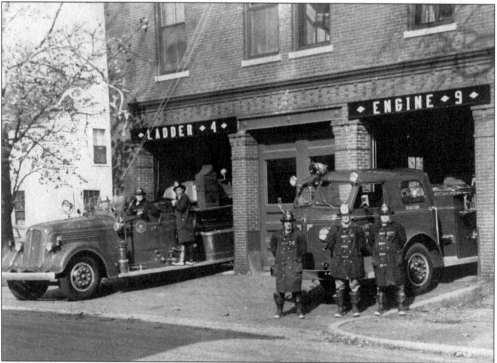

In a c. 1963 photograph, Engine Nine and Ladder Four are seen at the Arbor Street firehouse. Engine Nine is a 1954 American LaFrance with a 750-gallon-per-minute pump. Ladder Four is a 1944 Seagrave 65-foot aerial truck, a twin to Ladder One. The Arbor Street building still stands but is privately owned, although it maintains a very similar outward appearance today.

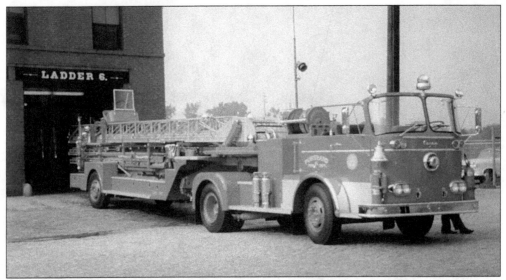

Seen in 1963, the 1961 Seagrave Ladder Six Tiller sits at the Park Avenue firehouse. This was the first 100-foot aerial for the department. It was also the last tiller. This apparatus was Ladder Six until 1978, at which time it was reassigned as Ladder Three. It was taken out of service in 1983.

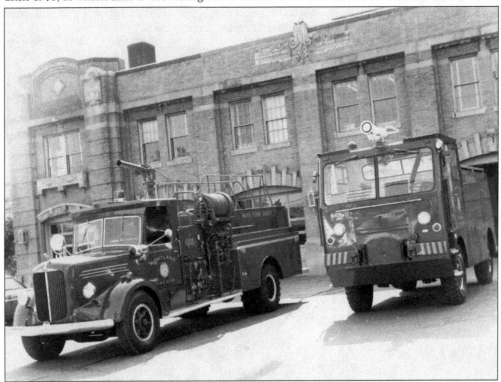

The Portland Fire Department's Air Rescue firefighting apparatus is pictured in April 1970. On the left is old Engine Three, a 1947 Mack with a 750-gallon-per-minute pump rebuilt into a 1,500-gallon foam tanker. On the right is a 1957 Ward LaFrance MB5 purchased from the Brunswick Naval Air Station. A second crash truck was purchased from Brunswick and added to the fleet in October 1970.

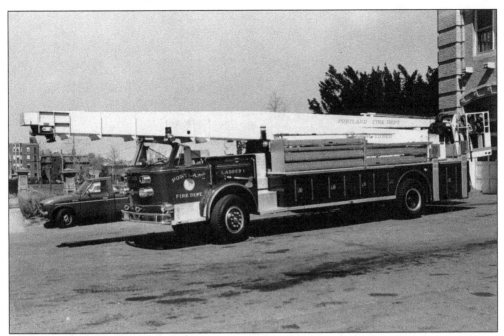

Ladder One is shown at Central Station in 1978 with its 1970 American LaFrance 80-foot aerial tower. This was the PFD's first articulating boom piece of ladder company apparatus. The aerial tower was used to get up and over wires in tightly packed areas like Munjoy Hill. The apparatus was reassigned to Ladder Four in North Deering in 1980.

Ladder Four is seen in 1980, running with a 1977 American LaFrance 100-foot rear mount aerial ladder truck. It was the PFD's first rear-mount ladder truck, with a four-section aerial ladder and the first pre-piped waterway. It was reassigned to Ladder One in 1980, then rebuilt in 1986 with a new cab with a roof. In 1989, it became a spare ladder.

In 1993, Ladder One received a new Pierce 85-foot snorkel bucket truck, replacing the 1978 Ward/Maxim 100-foot ladder truck. The department purchased the second articulating bucket truck because of the success the first 1970 truck had working up and over wires and rooftops at fires. The truck was refurbished in 2001 with a white-over-red cab and again in 2007. It was in service until 2016.

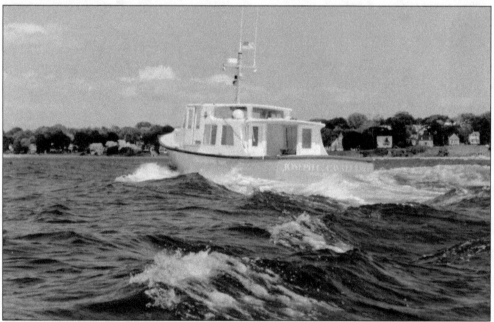

Seen in this 1996 photograph is the 42-foot Duffy and Duffy Company boat built in 1993 as an emergency boat. The vessel is named in honor of Joseph C. Cavallaro Jr., a PFD member who was killed in the line of duty at a three-alarm fire in 1980. The vessel is now designated as "Marine Two" during operations.

Four

FIRE COMPANIES

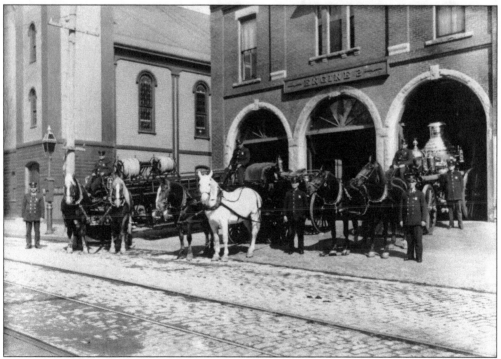

Munjoy Hill station is shown on May 15, 1913. From left to right are Ladder Two, Hose Two, and Steam Engine Two. Three different pieces of apparatus functioned under a single company, with one captain and one lieutenant. Any or all of the apparatus would respond from the station when an alarm sounded, depending on the nature of the alarm.

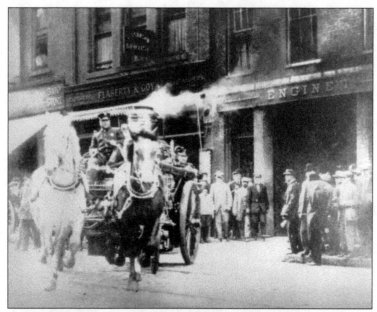

Engine Company One was organized on July 7, 1835, and continues as an active company on Munjoy Hill today. The company was located at various firehouses over its history. In this 1910 photograph, Engine One is seen leaving its firehouse at 555 Congress Street. Engine One was also quartered in firehouses on South Street, India Street, the new Central Fire Station, and both Munjoy Hill stations.

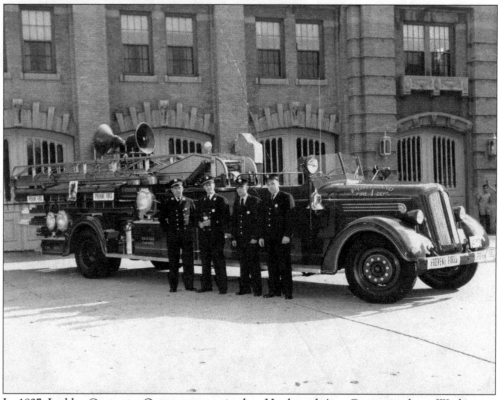

In 1827, Ladder Company One was organized as Hook and Axe Company, later *Washington* Ladder One. The original apparatus was hand-drawn until 1867, when a new ladder carriage was purchased and assigned horses. The company was located in several firehouses over the years. Ladder One is shown with its 1944 Seagrave at Central Fire Station, where it was quartered from 1924 until 1979. It was relocated to Munjoy Hill, and continues to operate there.

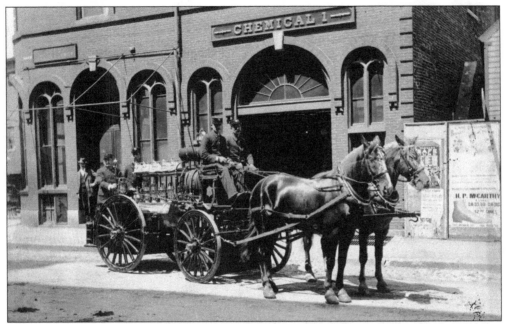

Chemical Company One was organized in 1892 and remained in service until September 1943. Chemical One's deactivation was tied to the organization of Rescue Company One on the same day. The company was originally located on the Market Street side of the old Central Station, responded to all bell alarms on the peninsula, and was a quick attack unit. This photograph was taken in 1895.

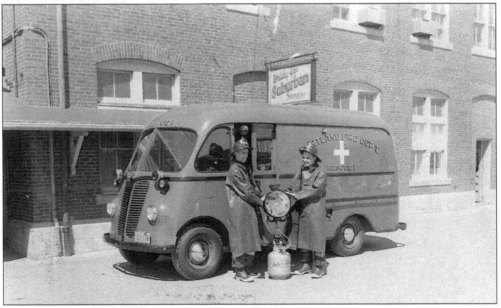

Rescue Company One was organized on September 8, 1943, with the mission to carry specialty tools and lighting. The second Rescue One truck, a 1948 International AM-152, can be seen in this 1952 photograph. Firefighters Stan Bailey (left) and Wilfred Hamilton demonstrate the use of a gas-powered floodlight. Rescue One has been staffed in many configurations and has been in reserve or decommissioned at times but continues to serve today.

Engine Two, seen at the Munjoy Hill station in 1963, was first organized in 1802 as *Cataract* Hand Engine Two. *Portland* Steam Engine Two was quartered in the Munjoy Hill Station in 1865. Engine Company Two was a double company from 1899 to 1929, with a steam engine, hose wagon, and ladder/chemical combination truck. Engine Two was deactivated on April 16, 1964.

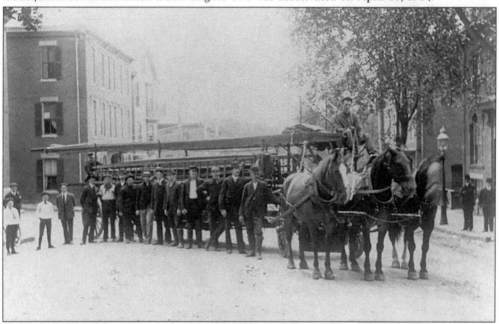

Ladder Company Two was organized in 1874 as *Eagle* Hook and Ladder Two. The company was first located in the *Casco* Five engine house. The company was relocated to the India Street firehouse in 1895. In 1899, Ladder Company Two was renamed Ladder Five. The Ladder Two company name continued at Munjoy Hill with Engine Two as a double company until deactivation in 1929. This photograph is from around 1889.

Engine Company Three was first organized in February 1836. The photograph shows *Cumberland* Steam Engine Three behind the men of Engine Company Three in 1885 at the 176 Brackett Street firehouse. The steamer was motorized in 1925 with a Christie tractor, though the horses on Hose Three were not retired until 1929. In 1983, Engine Three became a quint company, which was renamed Ladder Company Three in 2001.

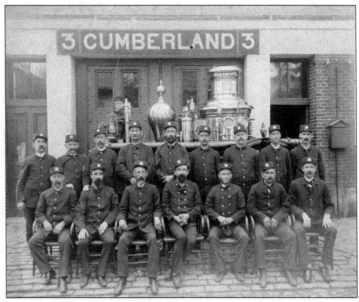

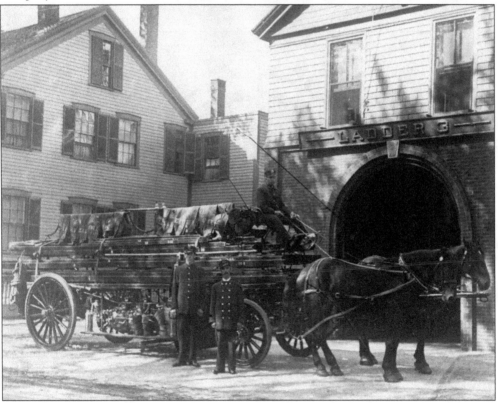

Ladder Three is seen on Brackett Street in 1912. Ladder Three, organized on March 5, 1883, was located in the West End on Brackett Street until 1966, when it was relocated to Engine 11's East Deering firehouse. In 1972, Ladder Three moved to Engine Three's Stevens Avenue firehouse in the Rosemont section when the additional bay was added. Ladder Three was changed to a quint company in 2001 and operates from Stevens Avenue today.

Engine Company Four was founded on March 24, 1837, with the hand-pump engine *Ocean*. Engine Company Four served the West End at the Spring Street and Bramhall Fire Stations until deactivation on September 9, 2013. Seen at the 157 Spring Street firehouse in 1962, Engine Four at the time was a 1960 American LaFrance 750-gallon-per-minute pumper. This firehouse is now the Portland Fire Museum.

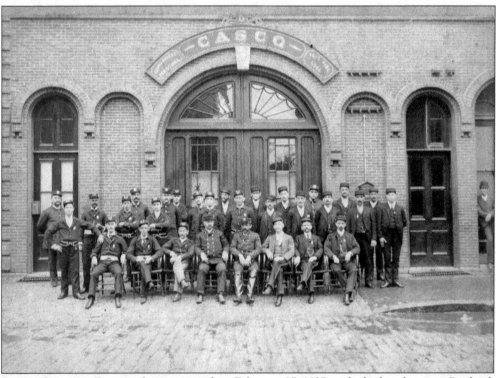

Engine Company Five was first organized on February 25, 1837, with the hand engine *Portland*. The company changed to *Casco* Five with a new steam engine in 1864. Nicknamed today "the Nickel" or "the Old Port Express," Engine Five is currently stationed at Central Fire Station. The members of *Casco* Five are seen in this 1888 photograph sitting in front of Old Central, at the corner of Congress and Market Streets.

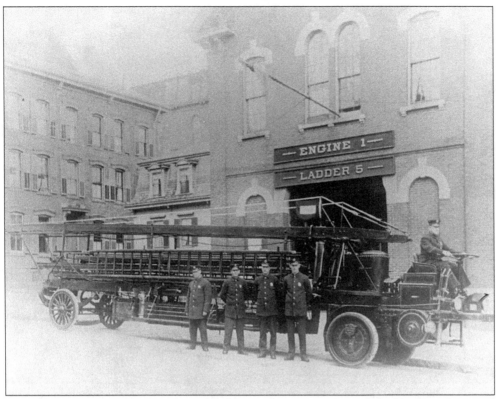

November 1, 1899, saw the founding of Ladder Company Five, formerly Ladder Two. Stationed in various firehouses, including India Street and both Old and New Central, Ladder Five was an active company until 1960. The motorized Ladder Five is seen in 1919 in front of the India Street firehouse. The tractor is a 1917 Christie hooked to the 1887 ladder carriage with the Hayes 85-foot wooden ladder.

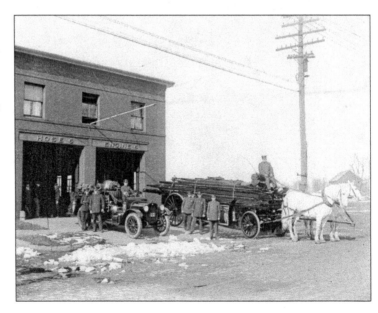

Ladder Company Six was founded on March 31, 1924, and stationed at the Park Avenue fire station. This 1924 picture shows the signs of Hose and Engine Six, as Ladder Six was first a part of a double company with Engine Six. Motorization in 1929 led to separation into two companies in 1930. At Park Avenue until the Bramhall Fire Station was opened, Ladder Six continues active today at Bramhall.

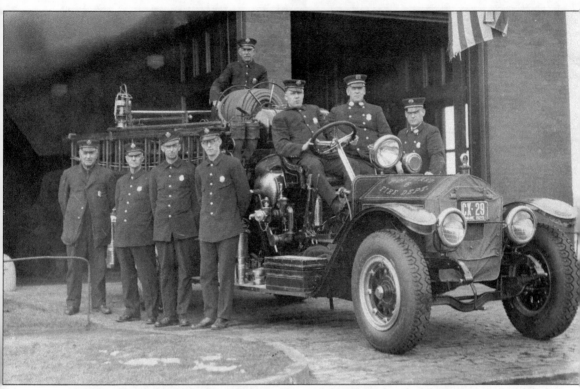

Engine Company Six can trace its inception to the 1794 *Vigilant* hand-pump engine and is the Portland Fire Department's longest serving active fire company. It was renumbered Engine Six in 1831. The company received its first steam engine in 1903 and motorized in 1921 with a REO hose and chemical truck. This 1929 picture at the Park Avenue firehouse shows the company with its 1916 American LaFrance, originally Hose Eight, which had been rebuilt with the addition of a 350-gallon-per-minute pump. This was the first motor pumper for the company. Serving today from Bramhall, Engine Six has been located primarily in the West End of Portland for its long career.

Formally organized in December 1894, the first fireboat was the former wooden ferry *Chebeague*. Engine Company Seven has always been the designation of the fireboat crew. Today, the PFD operates three vessels: the 65-foot *City of Portland IV*, the 42-foot *Joseph C. Cavallaro*, and a 20-foot skiff. During larger incidents on the mainland, the crew staffs Engine Seven, a reserve pumper housed at Central. This photograph was taken in 1900.

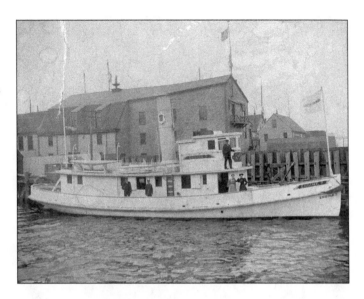

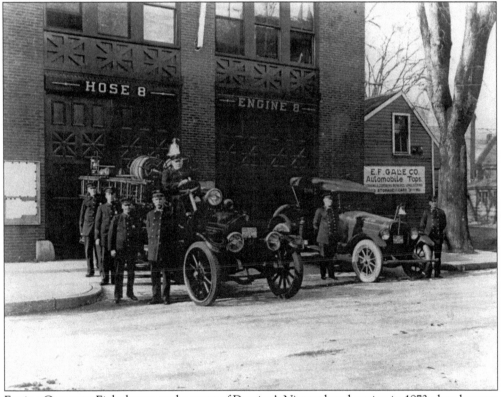

Engine Company Eight began as the town of Deering's *Niagara* hand engine in 1873, then became Hose One in 1889. In 1899, Deering Fire Department Hose One was renumbered as PFD Hose Eight. The photograph shows the 1908 Woodfords Corner firehouse in 1916 with Hose Eight and the District Two chief's Chandler car. The company was decommissioned in 2001, when Engine Eight, a quint company since 1982, was renamed Ladder Four.

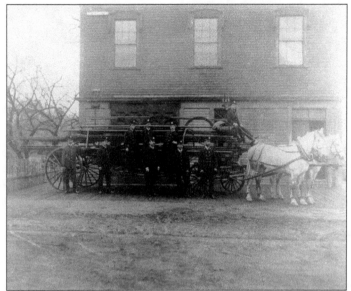

Ladder Company Four was organized on September 16, 1893. Originally Deering Fire Department Ladder One, stationed at Hose One's 165 Woodford Street firehouse, it became Ladder Four in 1899. Ladder Four, seen in this 1900 picture, is the 1874 Hunneman Truck, which had been rebuilt and assigned to Ladder Company Four. The company is active today and is stationed in North Deering on Allen Avenue.

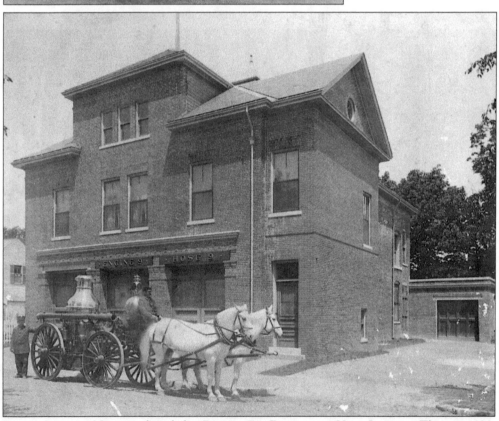

Engine Company Nine was founded as Deering Fire Department Hose Company Three in 1890, changing in 1899 to Portland Hose Nine. This 1903 photograph shows the Arbor Street station when Hose Nine became Engine Nine with the addition of the rebuilt 1870 Portland Company steam engine, originally *Cumberland* Three. Engine Nine continues today in the Riverton district, stationed on outer Forest Avenue between Morrill's Corner and Riverside.

Hose Company 11 was organized February 17, 1890, as Hose Five of the Deering Fire Department. In 1899, it was renamed Hose 11. It became Engine 11 in 1938 with the arrival of a Seagrave 500-gallon-per-minute motorized pumper, shown here in 1945 with members (standing from left to right) Capt. Michael Carlson and firefighters Oscar Dodd and Joe Thomas. Driver Tim Powell is in the driver's seat. The company continues today on Ocean Avenue.

Fire protection began on Peaks Island on October 13, 1884, with a used 1854 Jeffers & Company hand pump named *Forest City*. Shortly after a hose wagon and two permanent men were assigned in 1910, it became Hose 12. A REO motor truck arrived in 1921. A McCann 500-gallon-per-minute pumper replaced the REO in 1938 as Engine 12. Service continues today, staffed with a combination of fulltime and volunteer firefighters.

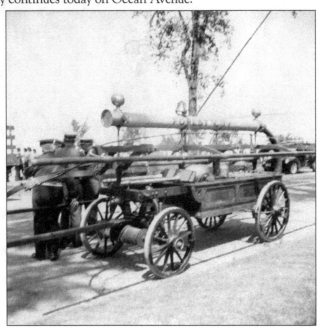

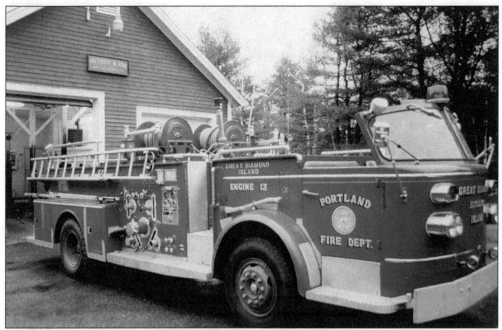

The US Army's coastal defense at Fort McKinley provided fire protection on Great Diamond Island from 1896 until it closed in 1947. A volunteer fire company was organized in 1949. Today, volunteers who reside on the island provide fire protection with assistance from the fireboat and mainland companies. Here is Engine 13, a 1963 American LaFrance 1,000-gallon-per-minute pumper, at the Great Diamond Island firehouse around 1989.

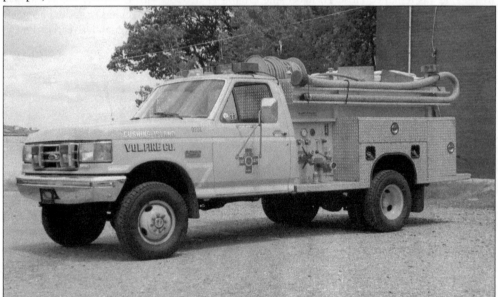

Fire protection on Cushing Island was provided by the US Army's coastal defense beginning in 1898 at Fort Levett until 1948. Island residents formed a volunteer fire company in 1997. Assistance is provided by the PFD's fireboat and land companies when needed. This photograph from 2007 shows a 1988 Ford F-350 4x4 one-ton 250-gallon-per-minute mini pumper with a 250 gallon tank, which is housed in the "Mule Barn."

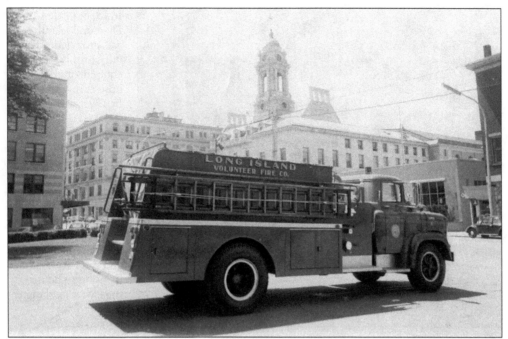

Though Long Island seceded from Portland on July 1, 1993, the former Portland island was provided with fire protection as early as 1908. In 1920, a motor chemical engine was assigned. During World War II, a military fueling depot was built, and other apparatus were located here. After the war ended, the depot closed in 1946 and a volunteer fire company was formed in 1948, later designated Engine 14.

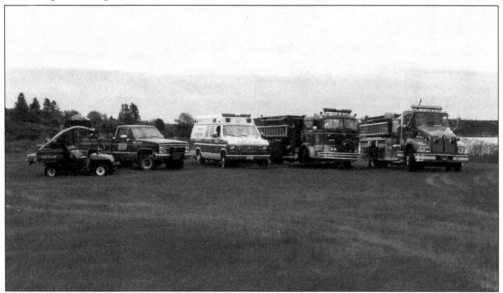

In 1908, Cliff Island received minor equipment for fire protection from the city, and it received a hand-drawn, two-wheel chemical jumper in 1925. A volunteer fire company was organized in 1952. In this 2004 photograph are, from left to right, ATV 15, a 1994 Kawasaki; Truck 15, a 1987 Chevrolet; Medcu 15, a 1987 Ford; Tank 15, a 1966 Mack pumper/tanker; and the new Engine 15, a Pierce/Kenworth 1,200-gallon-per-minute pumper with a 1,000-gallon tank.

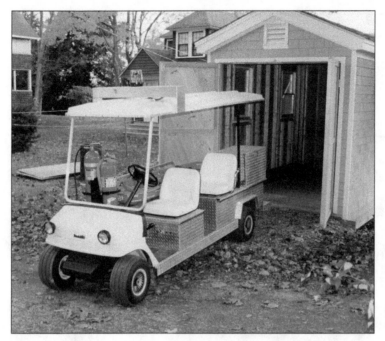

In 1958, Little Diamond Island was provided with minor tools and equipment and a hose cart with hose. In 1995, the island received this unique piece of equipment, a Yamaha golf cart carrying portable fire extinguishers, a stokes basket, and a portable 500-gallon-per-minute pump. A small shed was built by the fireboat members and the City Trades Division to house the cart. A volunteer fire company formed in 2002.

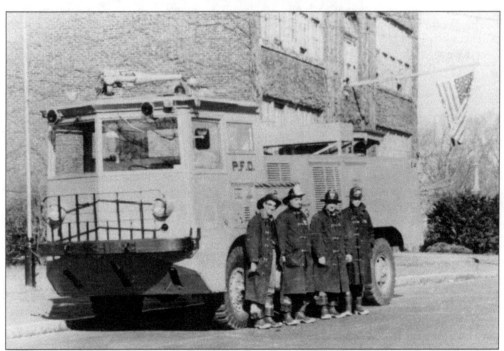

This 1953 American LaFrance O-10 crash truck was Portland's first air rescue firefighting truck, purchased in 1961 from Maine Civil Defense at Loring Air Force Base. Members of Engine Three, Engine Six, and Ladder Six operated the truck when needed. A permanent company was formed for the new Jetport fire station in 1973 and is active today. This photograph shows the truck at the Stevens Avenue station around 1962.

Five

DIVISIONS

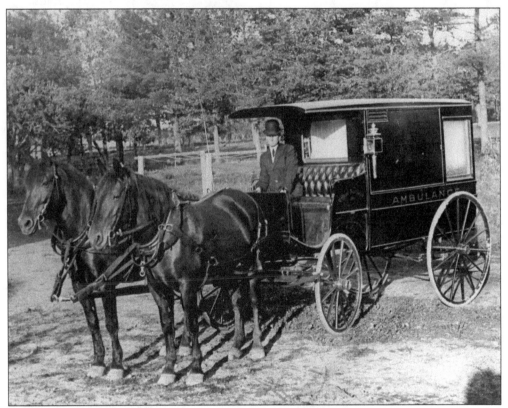

Early ambulance service was administered by the Portland Police Department, seen in this undated photograph. In 1975, a separate city department called Medcu, for Medical Crisis Unit, was created to provide ambulance service. In 1997, Medcu was integrated into the fire department as the emergency medical services division. Firefighters today are assigned to both fire companies and Medcu units with the skills needed to respond to all types of calls.

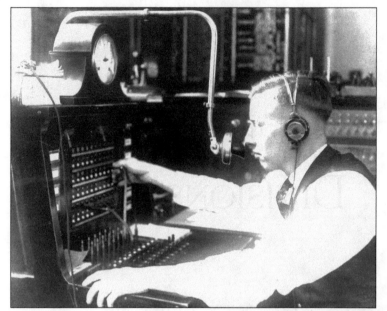

In response to the July 4, 1866, conflagration that burned over 1,500 buildings, Portland approved the installation of a fire alarm system. Installed in 1867 by Gamwell, Kennard & Company of Boston, the initial system consisted of 25 alarm boxes and eight-and-a-half miles of wire and cost $8,000. Seen at the operator's board in 1923 is fire alarm operator Alfred C. Stults.

Frederick Barnes Sr. was hired as a fire alarm lineman in 1895 and was promoted to superintendent in 1908. He served 32 years in total, 20 as superintendent, and held the title of assistant city electrician. Barnes served under Chief Oliver Sanborn, also the city electrician. Barnes's son, Frederick Barnes Jr., served the fire alarm division for 41 years starting in 1915, eventually as assistant city electrician as well.

The first Fire Alarm Division headquarters was on the second floor of Old Central from 1867 until relocating to the third floor of city hall in 1872. The headquarters operated in city hall until the building was destroyed by fire in January 1908, and is believed to be the point of the fire's origin. The building seen here was constructed at 118 Federal Street in 1909.

The Fire Alarm Division building at 118 Federal Street was in operation from 1909 until 1974. The building housed the office and dispatchers on the second floor. The first floor was the electrical shop. The lineman's truck, a 1969 Dodge, sits outside. The Franklin Arterial is seen in the background. Today, the division is on the third floor of the Public Safety Building at 109 Middle Street.

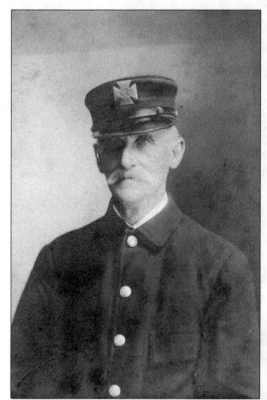

On June 27, 1905, Benjamin L. Sawyer, the driver of Hose Five, was reassigned as driver of the supply team with a horse-drawn wagon. His duties included delivering and picking up items at the Portland firehouses, including used hose from fires. The supply wagon was replaced with a second-hand motor truck in 1921. The division was active until 2009, when it was eliminated due to budget cuts.

The Supply Division initially consisted of the supply clerk with a stockroom of supplies, initially located at Old Central. It was moved to New Central upon its construction and remained there until 1979, when it was moved to the Bramhall Fire Station. The Supply Division continued at Bramhall until 2009. This 1978 photograph shows Service Truck One, a 1974 International three-quarter-ton pickup truck.

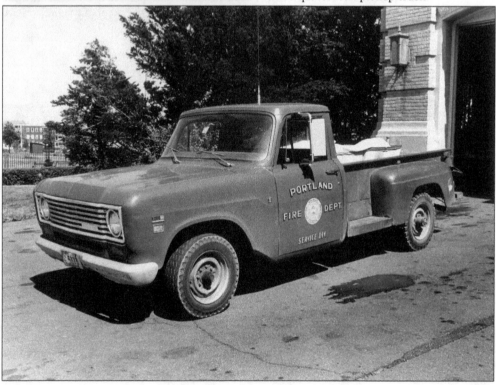

On May 25, 1907, Lt. Frank Carr of Engine Company Five was transferred to the chief's office to assist with paperwork, record keeping, and secretarial duties. He was promoted to the rank of captain and given the title secretary (clerk) of the Portland Fire Department, his office in the old and new Central Fire Stations. Peter Kane was the first civilian employee, hired in 1949 and retiring in 1976.

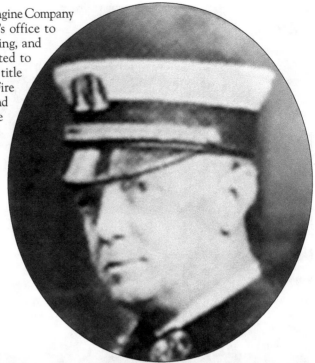

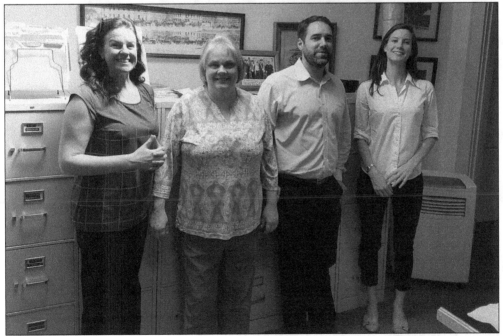

Today's Administrative Division has grown to meet the increasing demands of keeping one of New England's largest fire departments operating smoothly. Currently, four positions exist, with a fifth to be added in the near future. From left to right are senior administrative officer Amy Legere; accountant Heidi Waterhouse; principal financial officer Ben Bettez; and administrative assistant to the Fire Prevention Bureau Katharine Cahoon.

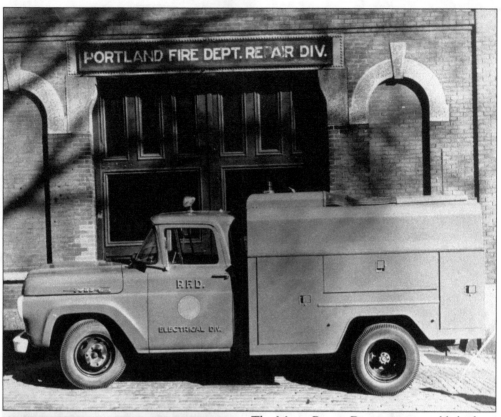

The Motor Repair Division was established on January 19, 1925, to maintain motorized apparatus. During the transition from horse-drawn to motor apparatus and during World War II, the division was also busy refitting vehicles for auxiliary functions. Seen in 1965, the former India Street firehouse was the shop from 1925 to 1929 and from 1953 until 1981. In front is the PFD Fire Alarm Division's lineman's truck, a 1960 Ford.

Alfred N. Pierce Sr. was the last fire department member of the Repair Division. He was the department mechanic from 1968 to 1987, working out of the India Street firehouse until 1981 and then at the Department of Public Works facility until his retirement in 1987. Today, the Department of Public Works assigns mechanics to cover the PFD. Joe Fournier has served as the department's mechanical engineer since 2000.

In 1929, Lt. Thomas S. Murdock was assigned by Chief Oliver Sanborn to attend a 40-day drill school conducted by the Boston Fire Department. Upon his return to Portland, the Training Division was launched with the creation of a 10-week set of drills each active member was required to complete. That year, a training tower was built at the rear of the firehouse at 295 Park Avenue. At right, firefighters train at the tower on October 10, 1929. The photograph below shows the training that took place during that first drill school. Lieutenant Murdock is seen on the rope, while firefighters stand under him holding what was referred to as a "life net" or a jumping sheet. The device was invented in 1887 by Thomas Browder and was in use until the 1980s.

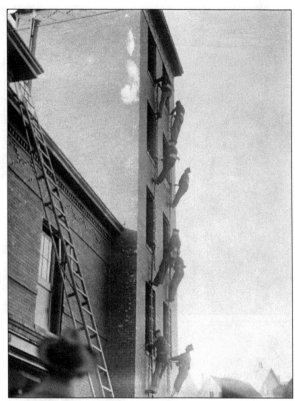

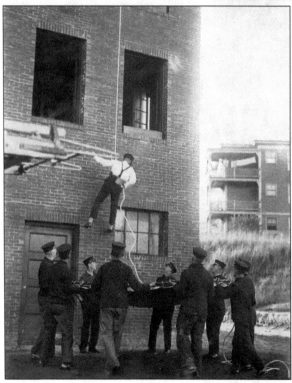

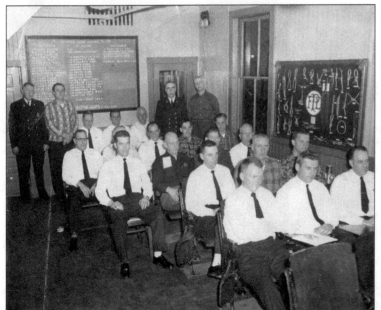

In 1932, it was decided that firefighters with the desire to advance their careers and become officers should receive additional formalized training via the Training Division. This is the 1958 officers school, taken at the quarters of Engine Seven. At that time, the fireboat was located at the State Pier, as it is today. Note the knot training board on the wall.

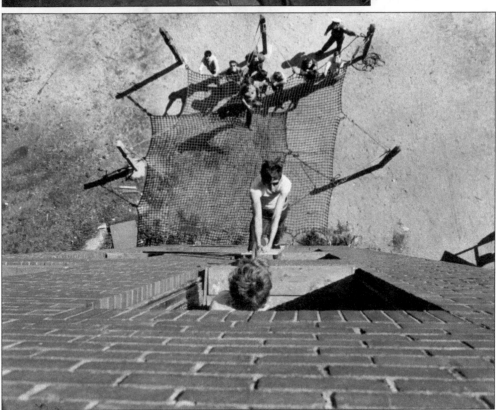

In a unique view from the Park Avenue training tower in 1974, another version of a life net can be seen under Loomis Jackson, the firefighter on the pompier ladder. This specialized ladder was used to scale the sides of buildings by hooking to the window above, climbing up and through the window, and repeating the process. The training captain, seen at top right, is Robert Davis.

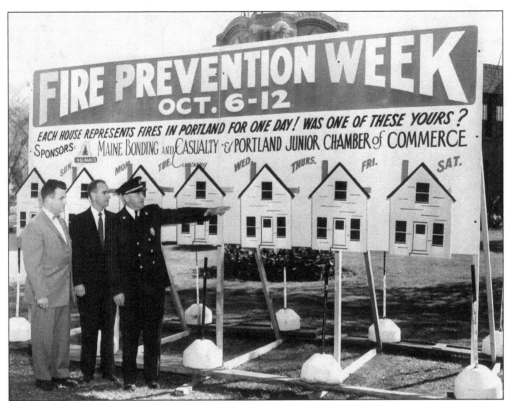

The Portland Fire Department
has participated in national Fire
Prevention Day since the first
was held on October 9, 1911,
commemorating the Great Chicago
Fire of 1871. Lionel Delaney (left)
of the Portland Junior Chamber
of Commerce and Robert MacRae
(center) of the Maine Bonding &
Casualty Company listen to fire
chief Carl Johnson as he discusses
Fire Prevention Week in this
October 6, 1957, photograph.

A system of daily and weekly
inspections performed by the
captains of each firehouse began
under Chief Patrick Flaherty in 1911.
A formal fire prevention bureau
was recommended by Chief Oliver
Sanborn in 1929 and was finally
established in 1940. Seen in 1957
are firefighters Leo Foisy (left) and
Joe Foley performing a routine safety
inspection in Engine Four's district.

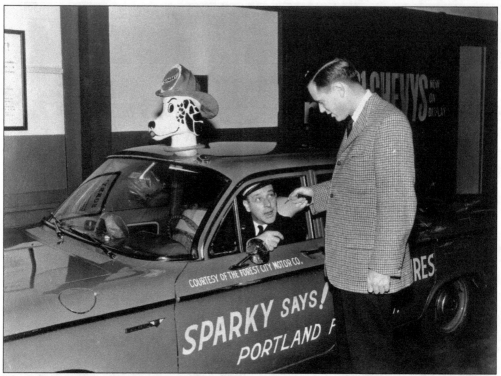

The PFD Fire Prevention Bureau receives a Chevrolet Corvair on November 30, 1960, courtesy of Forest City Motor Company. Forest City vice president Philip Gemmer hands the keys to Capt. Woodbury Ridley. The fire prevention mascot on the roof, "Sparky," was wired as a public-address system to provide information. Since the 1940s, the Fire Prevention Bureau has received consistent and numerous awards, both statewide and nationally.

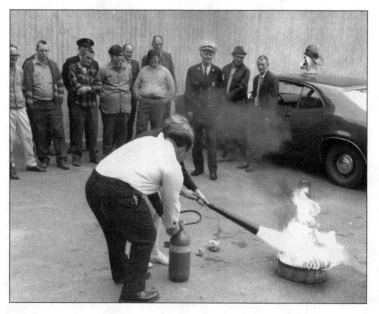

During Fire Prevention Week, the public is encouraged to learn and become more familiar with ways to prevent and even fight fire. Here, a civilian operates a fire extinguisher with the assistance of Lt. Joseph McDonough as other men and Capt. Samuel Gerber look on. A newer "Sparky" fire prevention car, a Mercury Comet, is seen at right. This photograph is dated October 6, 1971.

In 1975, Medcu was introduced as a part of the new Public Safety Department to meet the growing need for an ambulance service in Portland. This Medcu sign was located in the Medcu director's office at Bramhall Fire Station. Service began on February 18 with two new ambulances, which were received through a federal government grant. H. Edward Walker was appointed the first Medcu director.

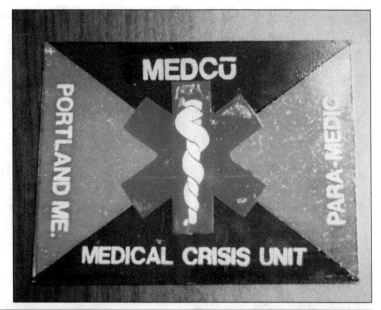

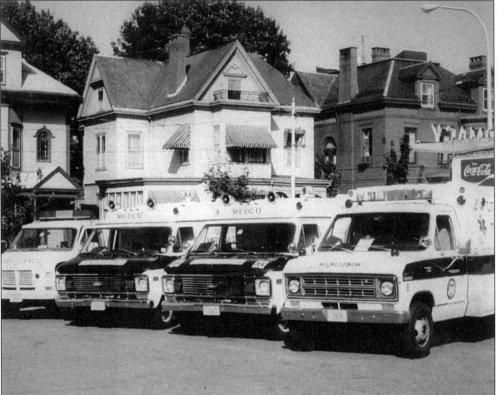

In this c. 1978 photograph, the four Medcu ambulances can be seen. From left to right are Medcu Five, the former police van used as a spare ambulance; Medcu Three and Four, the original 1975 ambulances; and the new 1977 Ford/Braun Medcu Three replacement. The 1975 Medcu Three became a backup ambulance. The photograph was taken on the Bramhall ramp, where Medcu Three was stationed at the time.

Medcu Four was stationed at the firehouse on Forest Avenue with Engine Nine in the Riverton section of Portland, shown here in 1981 with a new ambulance. A third unit went into service in 1990 as Medcu Five and was quartered with Engine Eight in North Deering. Medcu was integrated into the Portland Fire Department in 1997 after a fire training program to cross-train the Medcu paramedics as firefighters.

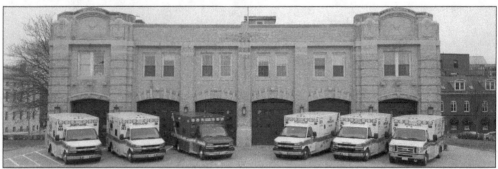

The Portland Fire Department today staffs two cross-trained members on each of five ambulances. The present Medcu fleet, seen from left to right, is Medcu Six at Bramhall, Medcu One at Munjoy Hill, Medcu Four at Allen Avenue, Medcu Three at Stevens Avenue, and Medcu Five at Central. Medcu Nine is a spare ambulance. Medcu Four is the first in a transition to red ambulances. (Courtesy of Autotronics.)

Six

MEMORABLE MEMBERS

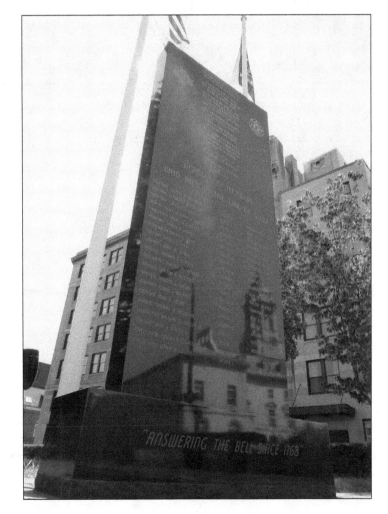

On Saturday, July 28, 2012, the Fallen Firefighters Memorial was dedicated on the west side lawn of Central Fire Station to Portland firefighters who lost their lives while protecting the city and its citizens. The memorial was almost 15 years in the making, with ground finally broken on September 9, 2011. Local civic leaders and businesses financially supported making the project a reality. (Authors' collection.)

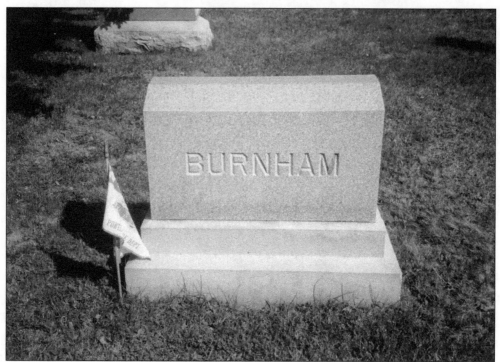

Hoseman Thomas W. Burnham, badge No. 51, of Engine Company Two, died on April 26, 1903, after being burned at Box 3-64, the Sturdivant's Wharf fire. Ex-hoseman Burnham joined the Portland Fire Department in 1856 and had retired in 1878, but was asked to assist on-scene. He and three other firefighters were trapped by fire and burned while trying to escape. He died two days later at age 68.

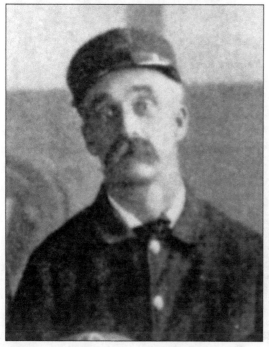

Hoseman Clarence A. Johnson, badge No. 41, of Engine Company Three, was also involved in the Sturdivant's Wharf fire, trapped by fire with ex-hoseman Burnham. He was severely burned and died of those burns on May 22, 1903, at age 47. He was a call man who had joined the Portland Fire Department in 1889.

Hoseman Charles W. Barrett, badge No. five, of Engine Company One, died as a result of electrical shock on Friday, October 2, 1908. A fire caused by arcing wires occurred in the basement of the Congress Square Hotel. The fire was successfully extinguished, and he exited the hotel to check on the wires. He inadvertently contacted a live wire and was killed instantly. He was 41 years old.

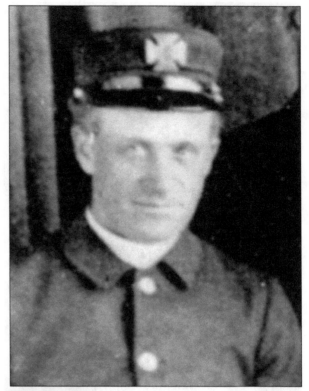

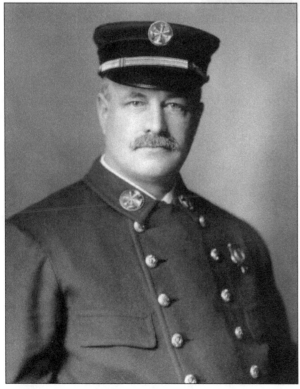

Deputy Chief William H. Steele died from exposure to nitric acid fumes on January 1, 1913. At 8:45 a.m., an alarm was struck for Hay's Drug Store on the corner of Free and Middle Streets, for a spilled carboy of nitric acid. It was quickly resolved, but six firefighters suffered adverse effects, including Deputy Chief Steele, who died that evening around 9:00. He was 46 years old.

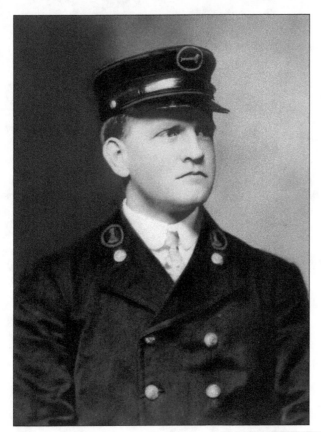

Lt. Ralph Eldridge, badge No. 136, of Chemical Company One, worked alongside Deputy Chief Steele in the battle against the nitric acid spill at Hay's Drug Store on January 1, 1913. As the effects began to take their toll on Lieutenant Eldridge, he was sent home for the night to recover. Unfortunately, he passed away the following morning at 4:00. He was 35 years old.

Harry Harmon, badge No. 130, of Engine Company Six, was working at Box 64, a two-alarm fire at the Royal Remedy Company, 432 Commercial Street, on March 7, 1913. Due to his exposure to smoke at the fire, he contracted pneumonia and passed away on March 18, 1913, at 41.

Ladderman Ralph E. Smith, badge No. 197, of Ladder Company Four, died from trauma sustained when he was thrown from Ladder Four while responding to an alarm at 100 Revere Street for a shed fire. The apparatus wheels caught trolley tracks, and Smith was thrown and subsequently run over by the horses and ladder carriage. The 31-year-old later succumbed to his injuries on September 4, 1915.

Capt. James C. Kent, badge No. 112, of Engine Company Six, died fighting the old Deering High School fire on Saturday, May 21, 1921. Captain Kent, 60, was fatally injured by a structural collapse that knocked him from a ground ladder and buried him beneath bricks. This was the sixth education building to catch fire that year, and it was thought to be arson.

Lineman John M. Hardy was a member of the PFD Electrical Division. On May 13, 1926, he suffered a fatal head injury after falling from a ladder at 85 Spring Street, where he had been changing fire alarm wires on a building. He passed away eight hours later. He was 23 years old.

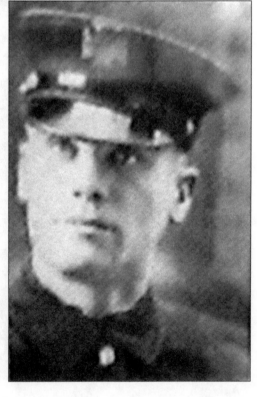

Pvt. Edward F. Fowler, badge No. 81, of Chemical Company One, was initially injured at Box 4-1291, a general alarm fire at the Winslow Pottery Company, 235 Forest Avenue, on October 24, 1927. Due to his prolonged exposure to both the cold weather and smoke that day, he suffered with chronic bronchitis for more than two years before passing away at age 33 on February 17, 1930.

Lt. Walter M. Jackson, badge No. 36, of Engine Company One, was taken to Maine General Hospital after smoke exposure at Box 43, a two-alarm fire at the Sacknoff Block at the corner of Commercial and Silver Streets on February 21, 1932. The 47-year-old lieutenant did not return to work and passed away due to heart disease on May 13, 1932.

Pvt. Walter P. Webster, badge No. 272, of Ladder Company Five, collapsed and subsequently died while working at Box 814, a two-alarm fire at 2B Monroe Place on August 22, 1932. The heart attack he suffered was attributed to overexertion and heat, as he had been working on the roof of the building. He was 56 years old.

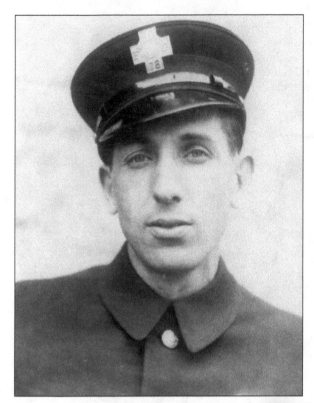

Pvt. Thomas L. Walsh, badge No. 78, of Engine Company Eight, died fighting Box 922, the three-alarm 780 Stevens Avenue Armory fire on February 24, 1945. Around 2:00 a.m., an explosion caused one of the building's brick walls to collapse. Walsh was crushed and died instantly. He was 39 years old.

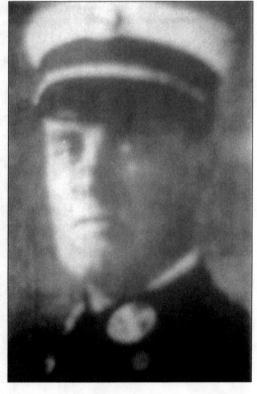

Capt. Frank J. Mullins, badge No. 2, of Engine Company One, died of a heart attack after working on an aerial ladder at a single-alarm fire on 17 Cove Street, May 3, 1952. He reportedly descended the ladder and collapsed. Captain Mullins, 62, passed away a short time later at 10:16 p.m.

Capt. John E. Tolan, badge No. 10, of Engine Company Six, passed away on August 27, 1956, while operating at Box 917, a two-alarm fire at 96 Highland Avenue. His cause of death was reported to be a heart ailment aggravated by smoke inhalation and asphyxia. He was 46 years old.

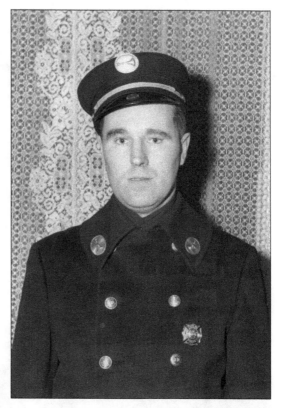

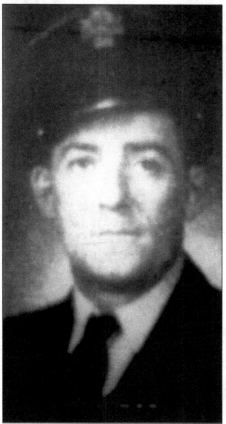

Pvt. Thomas G. O'Connor, badge No. 53, of Ladder Company Three, died on July 12, 1960, at Maine Medical Center from multiple traumatic injuries suffered the previous day in the collision of Engine Four and Ladder Three. Responding to an alarm on Orchard Street, the trucks collided at the corner of Spring and Brackett Streets. O'Connor was 43 years old.

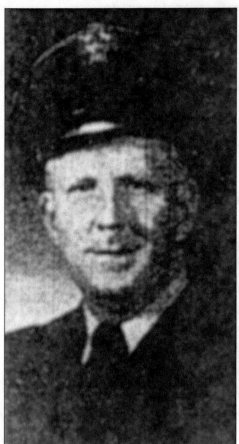

Lt. William E. Nugent Jr., badge No. 44, of Engine Company One, died on November 18, 1970, of a heart attack. Nugent had been hospitalized since suffering smoke inhalation operating at Box 52, a two-alarm fire at a three-building fire at 45-49-51 Parris Street on July 25, 1970. He never returned to duty. He was 47 years old.

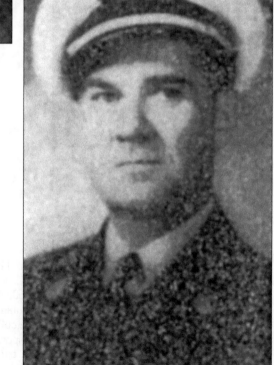

Capt. John F. Rafferty, badge No. 5, of Rescue Company One, died suddenly on January 30, 1972, while returning to the station after a medical emergency for a teenage girl suffering a drug overdose. Rafferty collapsed in Rescue One and subsequently passed away. He was 59 years old.

Firefighter Joseph C. Cavallaro Jr., badge No. 143, of Engine Company One, perished at Box 53, a three-alarm fire at the Phoenix nightclub, 83 Oak Street, on March 24, 1980. Cavallaro died of burns and asphyxiation occurring during the interior firefight. He was only 26 years old and had been a member of the department for two years at the time of his death.

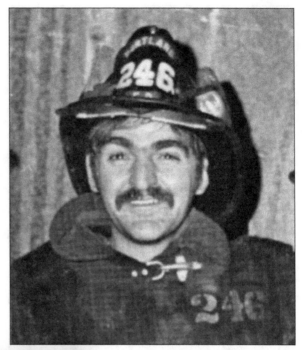

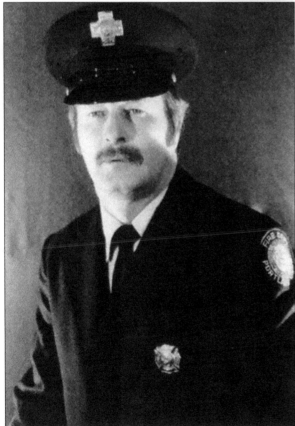

Firefighter Frank E. Cowan, badge No. 246, of Ladder Company One, died at home on September 14, 1993, of a heart attack. His death was directly related to originally suffering a heart attack performing ventilation operations at Box 622, a two-alarm fire at 629 Congress Street on January 5, 1993. Cowan was 44 years old.

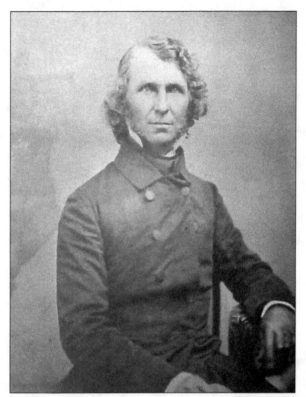

Neal Dow was a longtime Portland fireman beginning in 1827 as a member of the *Deluge* hand-pump engine, becoming director (captain) of the company. He was elected chief engineer of the fire department in 1839, holding the position until 1846. He was later elected mayor of Portland in 1850 and 1855. During the Civil War, Dow held the rank of general and was captured as a prisoner of war.

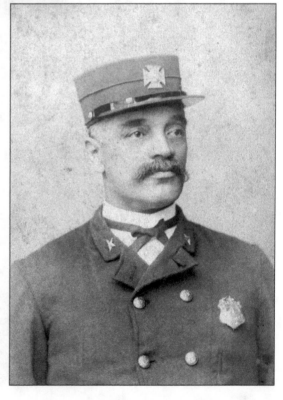

William Wilberforce Ruby served the PFD from 1884 to 1890. He originally served on *Machigonne* One and was elected foreman in 1886. He was elected assistant engineer in 1888, serving in the position for two years. He is believed to be the first African American PFD officer. Ruby is said to have first reported the 1866 conflagration. His father, Reuben Ruby, was a prominent leader in the Underground Railroad.

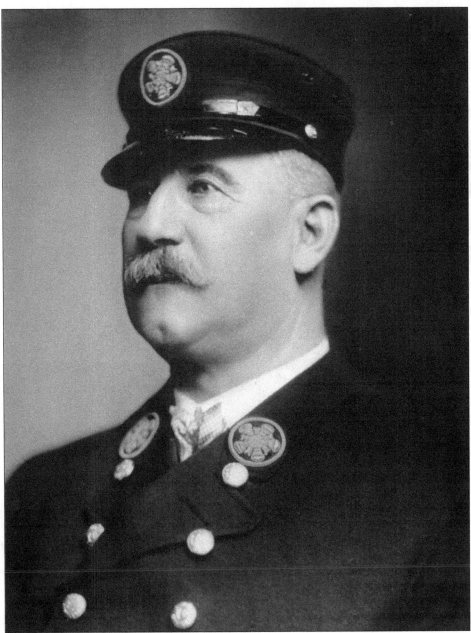

Chief Melville N. Eldridge served the fire department for nearly 40 years. He served as a call captain with Engine Three, residing across the street from the engine house for many years. He was elected assistant engineer in 1893 and elected chief engineer in 1896. During the annexation of Deering in 1899, he was appointed the first permanent fire chief. During his tenure, he coordinated a major reorganization of the department, increased the permanent force from 38 to 79 firemen, oversaw the construction of four additional firehouses, and upgraded most of the department's apparatus. Chief Eldridge was injured three times during the 1908 city hall fire and was finally carried to his second-floor office across the street at Old Central, where he continued to direct his men. He was known throughout New England as a progressive and well-respected fire chief. He retired in 1911.

Deputy Chief William R. Read joined the Deering Fire Department in 1889 with Hose One at Woodfords Corner. He was elected captain in 1897 and assistant engineer in 1903. He was appointed the first permanent district chief in 1910, quartered at the Engine Eight firehouse. In 1939, he was promoted to deputy chief. Still on the job, he became ill and died in 1942 with over 53 years of service.

Almus D. Butler became chief of the PFD in July 1914. He saw to the introduction of motorized equipment within the department beginning in 1915, when his own horse-drawn buggy was replaced with a Chandler Roadster. Over the next eight years, 12 more pieces of apparatus were motorized before Chief Butler retired in 1923.

Oliver Sanborn, a Bowdoin College graduate, was appointed chief in 1924. With 42 years in the department, 30 years as chief, he oversaw many positive changes. He opened New Central in 1924, completed motorization of the department, and established the Training Division and Fire Prevention Bureau. He also increased the department's strength and commanded hundreds of major fires. He retired in 1954.

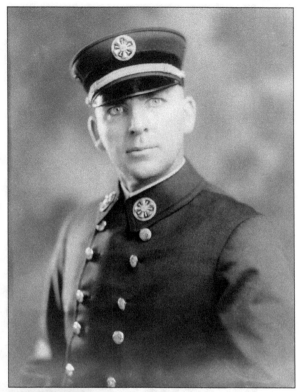

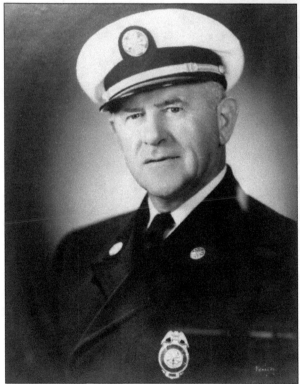

Carl P. Johnson was appointed to the PFD in 1927 and rose through the ranks to become chief in 1957, a position he held for eight years. During his administration, he began the consolidation of firehouses, greatly furthered fire prevention and educational programs (for which many national awards were given), and produced the Portland-made, nationally shown movie *24 Hours* in 1963. He retired in 1965 after 38 years.

On August 4, 1966, the opening day of the new Bramhall Fire Station, 14-year-old James P. Fox stood outside, watching Engine Four, Engine Six, and Ladder Six back into their new quarters. Jimmy lived on nearby Vaughan Street at the home of his parents, Dr. Francis and Catherine Fox. He would stop by the new firehouse at Bramhall Square daily, just watching the crews as they carried out their details for the day. A short time later, a firefighter invited him inside, and he instantly became a special member of the PFD family for the next 45 years. Dr. Fox told many of the firefighters over the years how appreciative he and his family were of the firefighters' camaraderie with Jim. The firefighters did not treat him as anything other than one of their own. Jimmy saw three generations of men and women pass through the department and was part of numerous fond and happy memories. He was made honorary deputy chief in 2003, and when he passed away in 2011, he was given a full firefighter funeral.

Seven

REMARKABLE FIRES

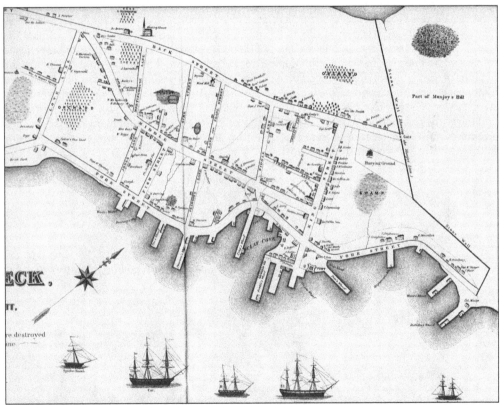

The third major conflagration occurred on October 18, 1775. Capt. Henry Mowat's Royal Navy fleet bombarded Falmouth (Portland) for 12 hours and sent men ashore to torch what was left. The dotted line identifies the burned area, stretching from Pearson's Lane (now Pearl Street) the length of Fore Street and up to Back Street (now Congress Street). There were 414 buildings burned, including the single engine house and the one fire engine inside.

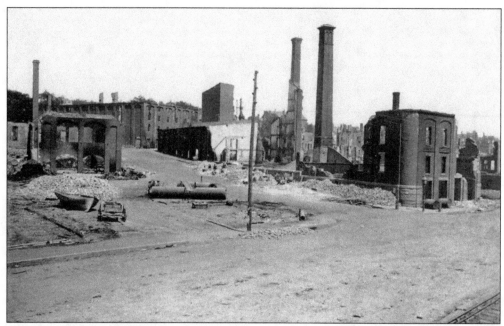

The extraordinary destruction of the fourth major conflagration on July 4, 1866, included the loss of over 1,500 buildings, and more than 10,000 people were left homeless. The fire is believed to have started near Commercial and Maple Streets, seen above. The stacks on the right are the remains of the eight-story J.B. Brown Portland Sugar House, covering most of the block between Commercial and York Streets. The building behind, fronting York Street, somehow survived and stands today. The photograph below was taken from the US Customs House looking northeast and shows the destruction and the post-fire living arrangement of tents for many of the survivors. Approximately 1,500 tents, sent from the US Army, made up a tent city on the side on Munjoy Hill, where the fire was finally stopped.

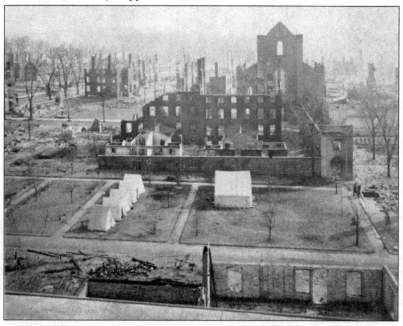

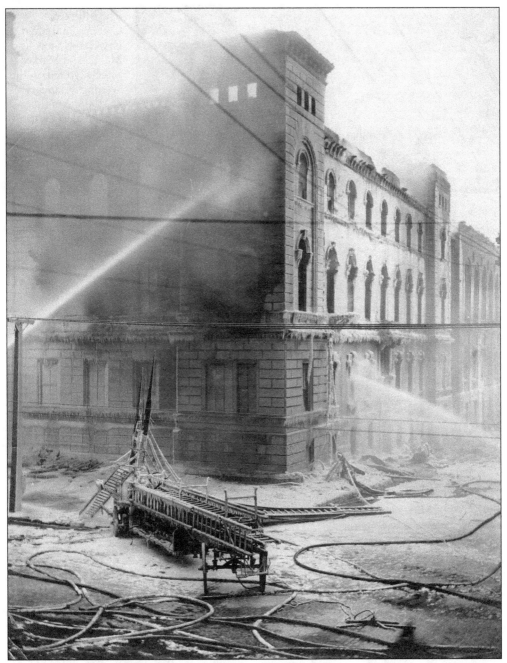

The Great City Hall Fire of January 24, 1908, is believed to have started in the fire alarm area of the building and was first reported by citizens seeing smoke and knocking on the door of Central Fire Station at 2:23 a.m. Chief Eldridge was injured three times at the fire, twice by fire brands and once by the collapse of the ice-encrusted Ladder Five aerial seen here. He continued to command the fire from his office on the second floor of Central Fire Station. Temperatures were between 10 and 14 degrees Fahrenheit, with winds up to 25 miles per hour. Flying brands set dozens of additional fires as far away as Maple Street. The general-alarm fire brought mutual aid from Augusta, Auburn, Bath, Biddeford, Lewiston, Saco, and Portsmouth, New Hampshire.

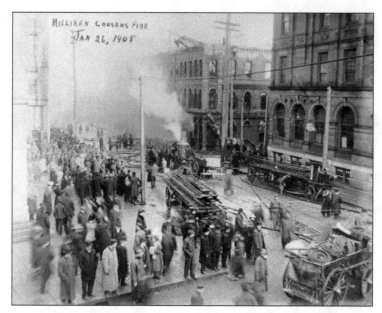

The Milliken, Cousens, and Short Dry Goods Store at Middle and Market Streets ignited on the evening of January 26, 1908. Another general alarm was struck only two days after the city hall fire. Fire had spread to all four stories of the building and to an adjacent building. On the right, Ladder Five, damaged at the city hall fire, is back in service with the broken aerial removed.

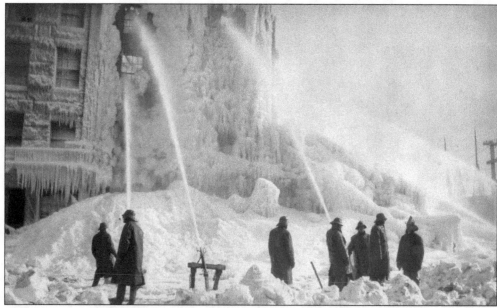

On February 23, 1914, three alarms were struck for 24 and 28 Commercial Street, the Galt Block Warehouse at the head of Galt's Wharf, located where the State Pier resides today. Below-zero temperatures and strong winds complicated the firefight. Though the fire was knocked down early the next morning, companies battled hot spots for weeks. The recall of the box, the official end of a fire, was never struck.

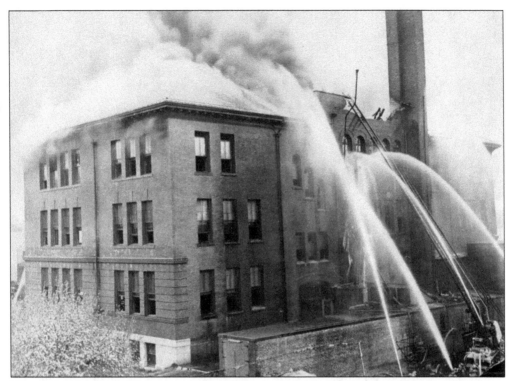

The original Deering High School burned on May 21, 1921. Multiple firefighters were seriously injured, Capt. James Kent fatally, when the front of the building collapsed. The fire was believed to have started in the library, destroying it and all the classrooms. Portland saw six public school buildings burn in one year, including Deering, and all were thought to be arson. The building stands and serves as Lincoln Middle School today.

The 320-foot-long, 50-foot-wide, six-masted schooner *Edward J. Lawrence* caught fire while in Portland Harbor on December 27, 1925. Engine Seven, a Coast Guard cutter, and two tugs all fought the fire in below-zero temperatures, but the wooden ship continued to smolder all night until it ultimately sank near Fort Gorges. It was the last of a fleet of 10 six-masted wooden schooners built between 1900 and 1909.

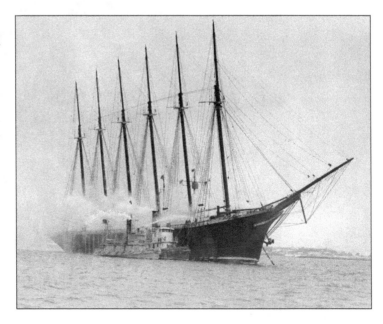

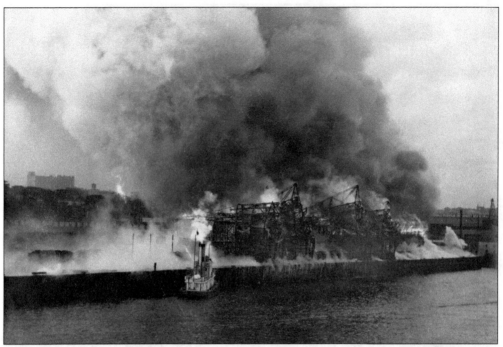

This eerie photograph shows Engine Seven, seemingly alone, battling the Portland Terminal Wharf No. One fire on September 16, 1929. The general alarm was struck on the fire. In total, 23,000 tons of sulphur burned. Eleven of the responding Portland Fire Department members were overcome by the fumes. Luckily, there were no fatalities.

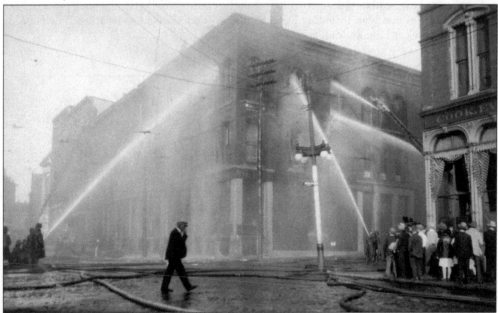

On August 17, 1929, at 1:47 a.m., Box 45 was struck for 143, 149, and 161 Middle Street, the Emery Waterhouse building. The general alarm was eventually struck. This was the last fire for which a steam pumper was used (old Engine Three), which was a reserve piece of apparatus housed at the Arbor Street firehouse.

On the bitterly cold night of February 3, 1931, Box 86 went to four alarms for the Williston Church, at 32 Thomas Street. The initial alarm came in at 6:57 p.m., and the firefight went through the night. The church organ was listed among the major losses.

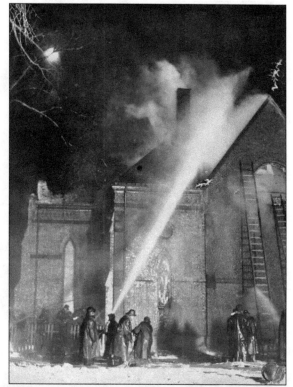

Three alarms were struck for Box 8 on October 29, 1933. Responding companies found significant fire spread throughout the former Ayer, Houston & Company Hat Factory at 2 Beach Street. The initial alarm came in at 6:52 p.m., escalating to a third alarm by 7:08 p.m.

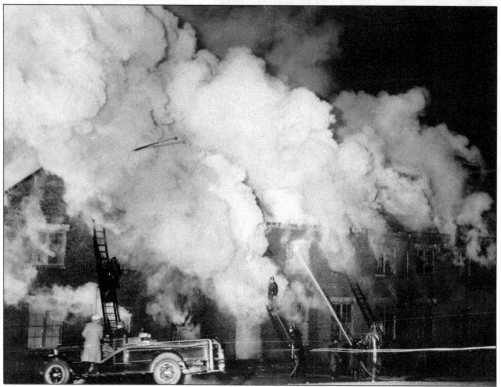

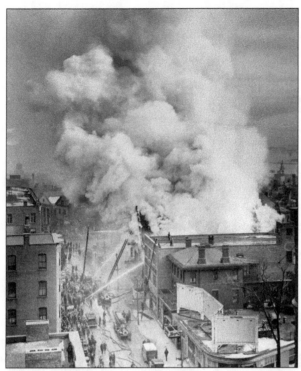

Three alarms were struck for Box 621, the Recreation Building at 616 Congress Street, on January 9, 1934. The alarm came in at 10:36 a.m. with fire visible from the upper floors. Reportedly, the fire started in the State Ballroom, built to hold 900 people. A backdraft was said to have blown four firefighters back through a doorway, but the fire was considered under control around noon.

Box 64 was struck for a fire that eventually destroyed the Hobson's and Berlin Mills Wharfs on December 6, 1934. This aerial photograph shows the fire sweeping through a 300-yard section of Commercial Street, destroying both wharves and several vessels, with damages over $200,000. The fire was not under control until the next day.

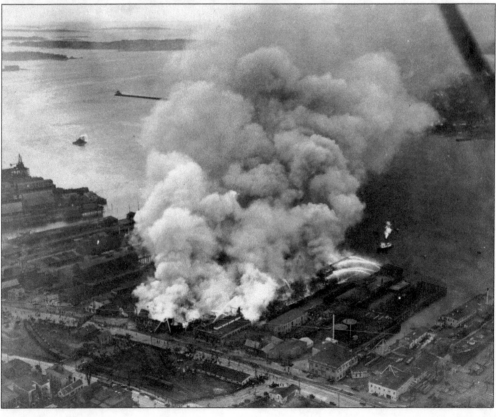

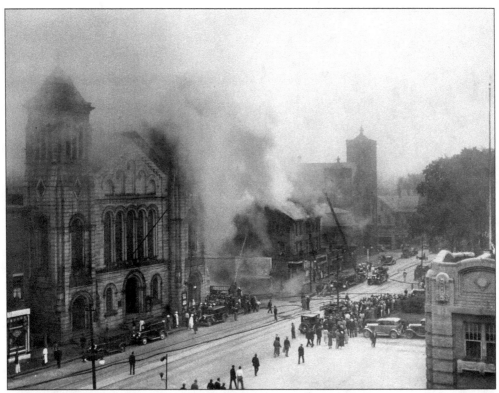

July 9, 1935, saw Box 48 struck for a fire at 361 Congress Street, at the corner of Pearl Street. A commercial space occupied the first floor, with residential units on the floors above. Central Fire Station can be seen in the foreground. Close inspection of the background activity along Congress Street finds widely respected ladder techniques Portland helped pioneer with the Boston Fire Department.

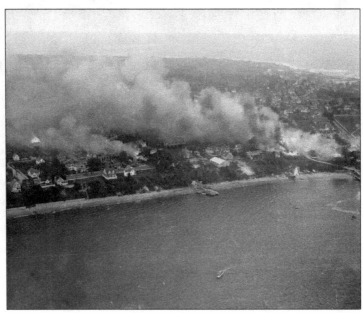

Peaks Island saw more than 40 structures burn on June 2, 1936, including 33 homes and cottages, six stores, the 1884 Gem Theater, and the new Union House Hotel. This aerial view shows separate significant spot fires visible to the left, a real challenge in mitigating a fire of this size. The Peaks Island firehouse can be seen directly behind the double-dormered waterfront house.

Ladder Three dramatically displays the hardship of winter firefighting in New England at a two-alarm fire at 28 North Street on March 4, 1944. The fire reportedly started in the attic and spread quickly before being discovered by the owner, who then ran to the Munjoy Hill station to report it. Box 25 was struck at 4:22 p.m., the second alarm seven minutes later.

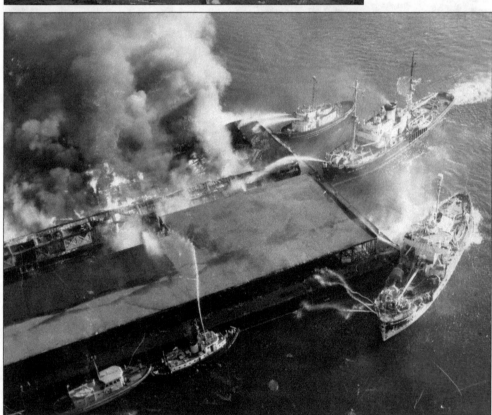

The 1,000-foot-long State Pier caught fire on October 23, 1947. Box 29 went to three alarms and caused an estimated $700,000 in damage. Two firefighters were injured in the battle. This fire occurred during the hot, dry summer of 1947, when the PFD responded to 24 calls for mutual aid from nine cities and towns during the widespread forest fires.

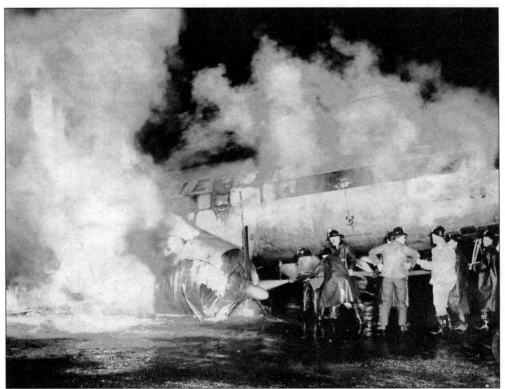

A Northeast Airlines flight with 29 souls aboard crashed at Portland Municipal Airport on Thursday, August 11, 1949. Passengers reported fleeing through the rear of the burning aircraft with the aid of one particularly composed stewardess on board. Amazingly, there were no casualties. Dealing with the size and scope of this incident exposed the lack of dedicated air rescue firefighting apparatus, as Portland did not have a dedicated crash truck until 1961.

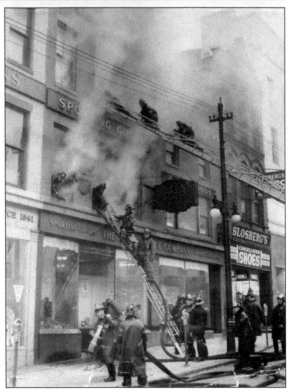

Two alarms were struck on Box 413 at 264 Middle Street on April 25, 1950. Though the men were appropriately outfitted for that era with their long coats, tall boots, and helmets, there was no breathing apparatus in use for the firefighters. It is incredible to observe the men on the second and third floors of this building. During this era, firemen were truly "smoke eaters."

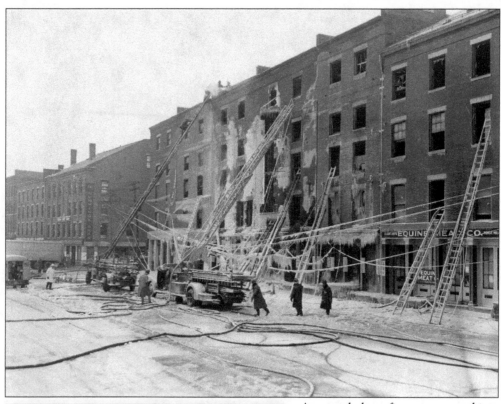

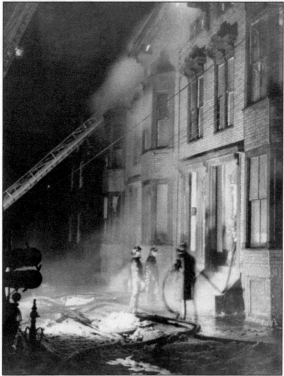

A general-alarm fire was reported just before midnight on January 30, 1952. The fire raced through five stories of the James Fruit Company building at 223–229 Commercial Street. It was caused by a cigarette left smoldering. The firemen had to deal with subzero temperatures during the fire. The losses were reported at $150,000, with $50,000 of the losses being fruit. (Courtesy of Arthur Best.)

This January 6, 1956, three-alarm tenement fire on Box 41 at 22, 24, and 26 Deer Street made for a long, cold night. Deer Street was located in the heart of "Little Italy," surrounded by Fore, Franklin, Middle, and Pearl Streets. The neighborhood was demolished in 1958 as part of a redevelopment of the Vine-Deer-Chatham Street area.

The general alarm was struck on May 26, 1964, for the Maine Lumber Company at 55 Bishop Street at Morrill's Corner. Originating in a 185-by-30-foot wooden shavings building, flames reached 100 feet in the air. The fire endangered more than two million board feet of lumber in the main building, only 20 feet away. The main building was successfully defended and escaped damage.

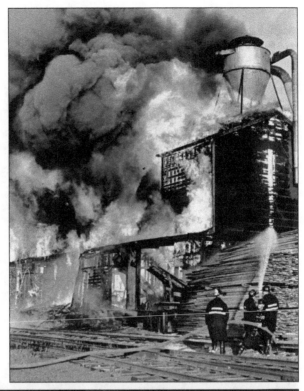

Three alarms were struck on Box 413 at 2:27 a.m. at the Capri building, a large business block at Middle and Temple Streets. Flames high in the air greeted the arriving Central companies, responding from only a few blocks away. Companies remained on scene until the following afternoon, and the loss was estimated at $250,000.

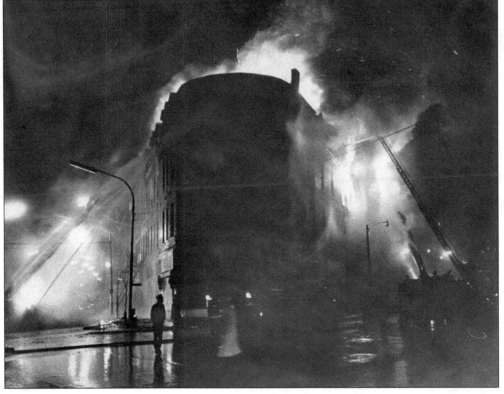

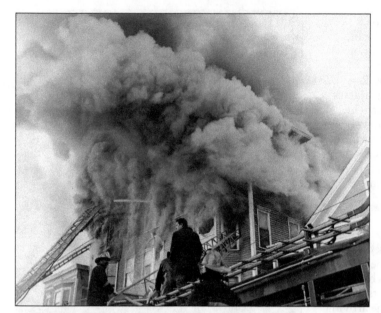

Three alarms were struck on Box 763 at 849 Congress Street on February 2, 1969, near Weymouth Street, only blocks from the Bramhall Fire Station. People were trapped in the large, four-story, wood-frame multifamily building with fire on the top floor and extending to the cockloft. Though sadly one man perished, Portland firefighters displayed exceptional rescue and ladder work at this fire.

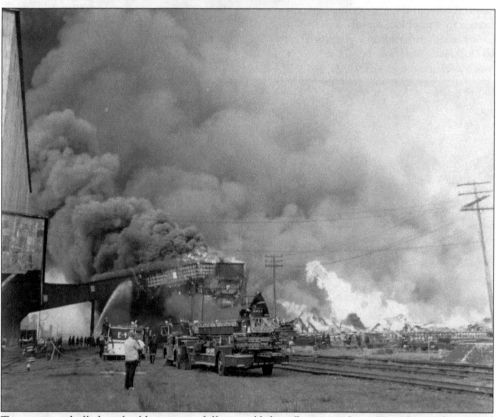

Two piers and all their buildings were fully engulfed in flames on June 27, 1970, at the Grand Trunk general-alarm fire at Commercial and India Streets. Engine Seven, bracing against a tug to remain steady, sprayed water onto the massive fire in the rear. The fire was cut off in the long conveyor belt to the 170-foot-tall grain elevator building, which had the potential to explode.

Ladder One and Engine Five engaged in defensive operations at a three-alarm fire at 105 Middle Street, the four-story Eagle Press and Printing Building. The initial alarm came in at 4:37 a.m. on November 5, 1970. Note the hose running up Ladder One's aerial, not often seen today, as present-day aerials generally have pre-piped waterways.

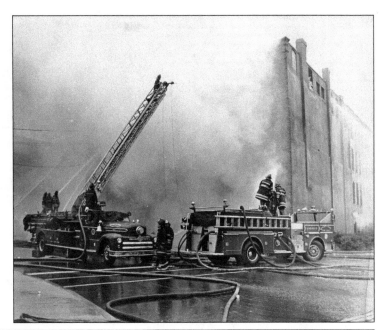

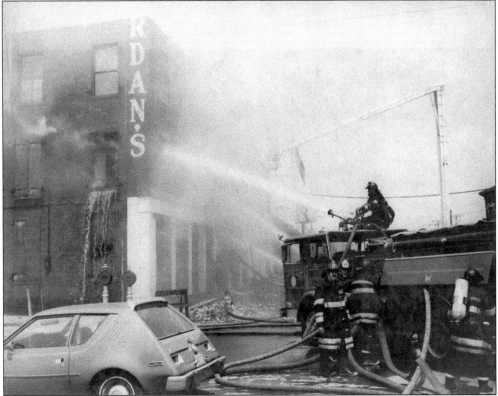

Two alarms were struck on Box 43 at the Jordan Block on Commercial Street on June 1, 1976. The building was under demolition when it caught fire and workers became trapped inside. Ladder One, the aerial tower in the background of this picture, reportedly made outstanding rescues at great risk to themselves before an extensive defensive operation controlled the fire.

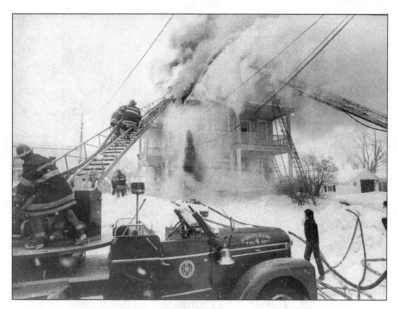

January 14, 1977, was a cold, snowy morning. A fire broke out in a two-story apartment house at 68 Wolcott Street. This photograph shows the obvious difficulty the firefighters had with the snow and freezing temperatures. Two aerials and ground ladders were utilized in the battle against the fire.

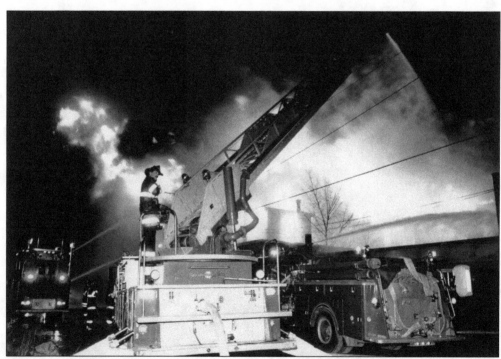

Three alarms were struck for the Portland Stove Foundry fire on the bitterly cold evening of February 23, 1989. In total, 29 units were operating or on standby at the scene until the fire was under control. It was reported that this fire was the biggest the department had fought in many years. The foundry was located between Kennebec, Somerset, Pearl, and Chestnut Streets.

110

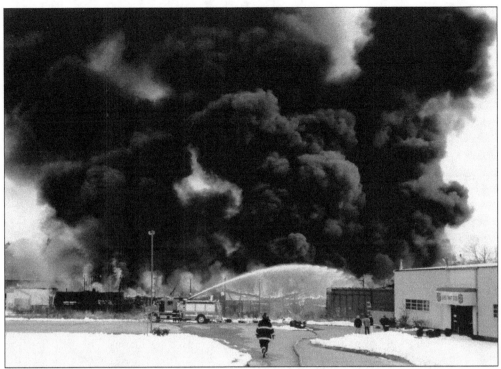

March 16, 1998, found the PFD dealing
with a four-alarm warehouse fire at 75
Bishop Street. A storage building was also
destroyed in the fire, set by two teenagers.
Mutual aid apparatus was brought to
the scene and assisted with coverage at
Portland's fire stations. Evening commuter
traffic was brought to a standstill at
Morrill's Corner because of the blaze.

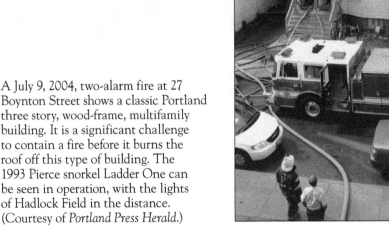

A July 9, 2004, two-alarm fire at 27
Boynton Street shows a classic Portland
three story, wood-frame, multifamily
building. It is a significant challenge
to contain a fire before it burns the
roof off this type of building. The
1993 Pierce snorkel Ladder One can
be seen in operation, with the lights
of Hadlock Field in the distance.
(Courtesy of *Portland Press Herald*.)

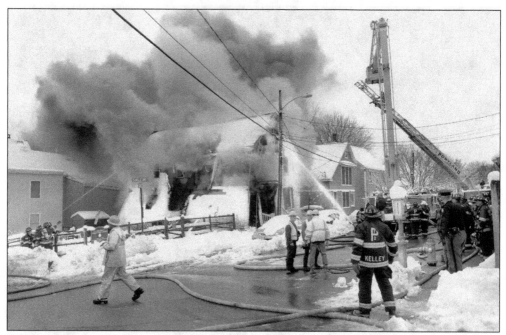

A gas explosion at 36 Salem Street on April 5, 2007, went to three alarms. The force from the explosion caused the house to shift from its foundation, requiring demolition crews to take the house down later that same day. Note the wall on the left side of the house, which bowed out significantly when the building shifted.

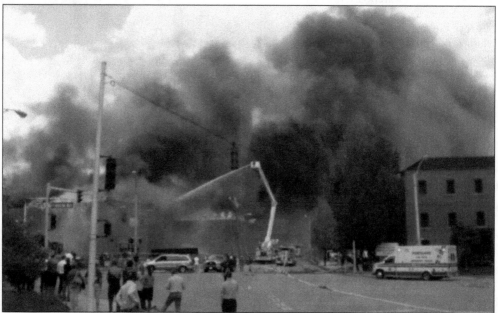

Just after 1:00 p.m. on May 6, 2010, the old Jordan Meat plant at 38 India Street caught fire during demolition. The second alarm was struck immediately upon the responding crews seeing the smoke column en route. The third alarm was struck shortly after that. About 100 firefighters, including mutual aid, brought the blaze under control by nightfall. A small crew remained on scene through the night.

Eight

THE PORTLAND
FIRE MUSEUM

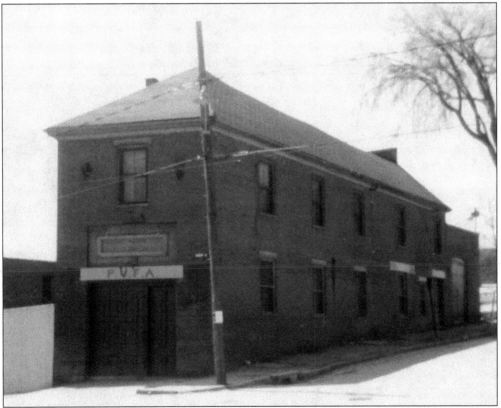

The South Street engine house at the corner of Spring Street was built in 1836 for *Casco* Hand Engine One and was later used for storage. In 1895, the city authorized the Portland Veteran Firemen's Association, organized in 1891, to use it as a meeting place and for displaying artifacts of the fire department's history. The building was vacated in 1971 and razed for the widening of Spring Street.

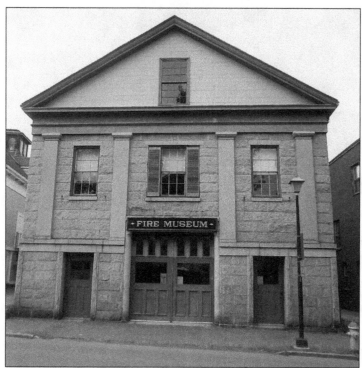

The Portland Fire Museum is located at 157 Spring Street, near State Street. It was originally built in 1837 for PFD's *Ocean* Engine Company Four with the Ward Six meeting room in the back on the first floor, and the West End Female Grammar School on the second floor until 1869. It closed in 1966 after 129 years as an active firehouse. It later opened as the Portland Fire Museum in 1974.

This photograph shows artifacts in the second-floor meeting room used by the Portland Veteran Firemen's Association and the Box 61 Firebuff Club, a civilian organization that formed in 1961. Artifacts from the South Street veterans' hall had been wrapped and boxed by a moving company and transported to the new fire museum at old Engine Four, and were later set up for display by members of both organizations.

The second floor also contains display rooms for chief officers, badges, prints and photographs, log books, records and maps, and a civilian defense and 9/11 room. The center gallery and hall has many pictures and artifacts, such as the display case containing a model of Engine Seven, the 1959–2009 fireboat, which is seen in this photograph, along with items from the boat. The meeting room is in the background.

On the first floor in the back left corner, where three horse stalls stood until 1929, are the fire alarm telegraph displays. This contains a large box alarm circuit board, battery boards, and the fire alarm operator's switchboard. This equipment was moved to the fire museum from the former Federal Street fire alarm office after it was closed in 1974 to make way for the Franklin Arterial.

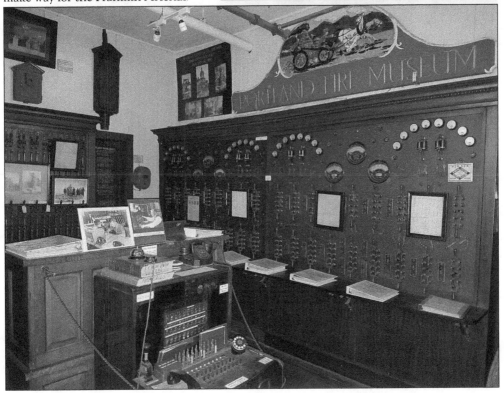

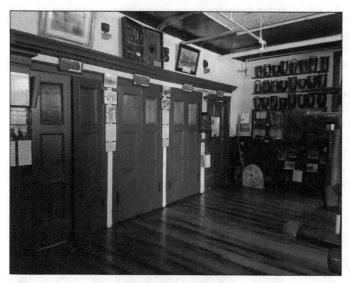

This photograph shows Portland's last three remaining horse stalls. Equipment and photographs are now displayed inside. During October, they are removed, as privately owned horses are placed in the stalls during the annual open house. Also, note the 1929 hardwood floor, which was voluntarily repaired in 2005 by Portland's talented firefighters. Without their help and support over the years, this would not be known as a "second-to-none" museum.

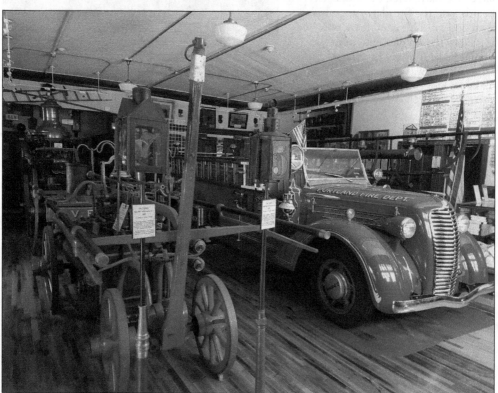

Seen here are the 1848 hand-pump engine *Atlantic* Two, the "Torch Boy" poles, the 1938 McCann motor pumper (Engine 12), and the 1854 Jeffers & Company hand engine *James B. Plaisted* (formerly Peaks Island's *Forest City*) on the right. Thanks to forethought and dedication from Portland Veteran Firemen's Association members beginning in 1891 to today's Portland firefighters, the city of Portland has one of the most comprehensive collections of firefighting artifacts in the country.

Nine

THEN AND NOW

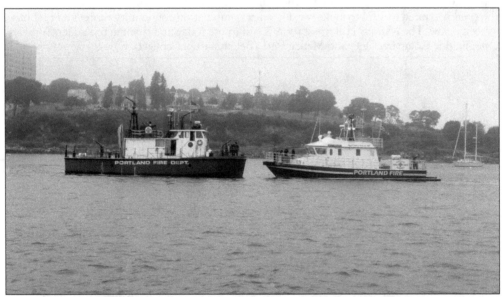

In a display of the passing of the traditional designation of Engine Seven, the new 2009 A.F. Theriault–built *City of Portland IV* (right) arrives from Nova Scotia on July 26, 2009, and is seen "kissing" the 1959 *City of Portland* fireboat, retiring after 50 years of service. The Eastern Promenade is in the background. (Courtesy of Lt. David Crowley.)

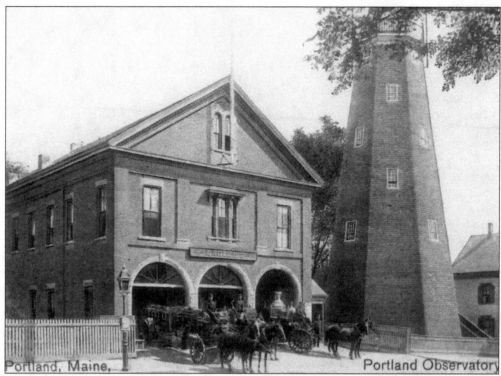

The photograph above shows the 1864 Munjoy Hill Engine House at 134 Congress Street, next to the Portland Observatory, which was built in 1807. Originally, it had one bay door in the center. Two more adjacent bay doors were added in 1899. At that time, Steam Engine Two, Hose Company Two, and Ladder Two were stationed at the building. This firehouse, which housed Engine One at the time, was razed in 1976 to make way for a new combination community center and firehouse, as seen below. The Munjoy Hill fire station is still in use today and is home to Ladder Company One, Engine Company One, and Medcu One (Below, authors' collection.)

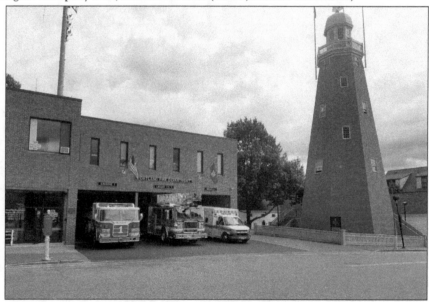

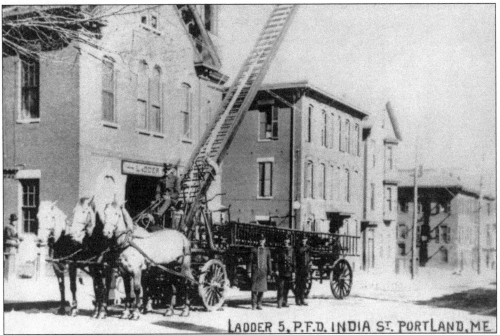

LADDER 5, P.F.D. INDIA ST. PORTLAND, ME.

India Street was home to many different companies, including Steam Engine Four, Ladder One, Ladder Two, Ladder Five, Engine One, and the Repair Division. Ladder Five is seen above in 1900 with the 1887 Hayes two-section, 85-foot wooden aerial in front of the India Street firehouse. The view is south down India Street toward the water. Below, though not housed here, is Ladder One, the newest ladder truck in the PFD. The 2017 Seagrave 105-foot steel aerial is shown with Lt. Justin Bragdon and firefighters Jeb Gerrish and Craig Voisine. Ladder Five is still used as the PFD's spare ladder, and Ladder One is the active ladder company that protects the Munjoy Hill section of the city, including India Street and the old firehouse, which has been converted for office use. (Below, authors' collection.)

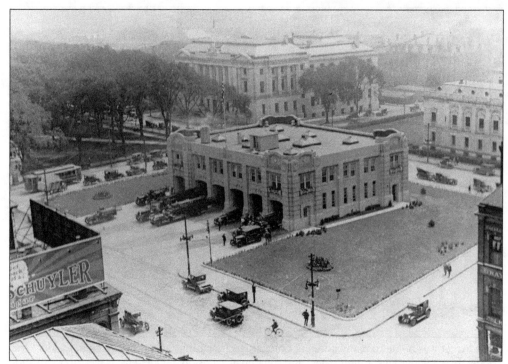

Central Fire Station was dedicated in August 1925, seen above from the bell tower of city hall. The apparatus assigned to Central at that time, mostly on the ramp in the picture, included Chemical One, Engine Five, Engine One, Ladder One, and Ladder Five. The cars belonging to Chief Oliver Sanborn and district chief William Read are also visible. Below, Central is seen with the current active companies (from left to right) Engine Seven's engine, Medcu Five, Engine Five, Car One (Chief David Jackson's Ford Explorer), and the Paramedic Supervisor Nine Ford Explorer. Though the original was taken on an overcast day, the recreation was purposefully taken on a sunny day to show off the bell tower's views of the city, the islands of Casco Bay, and Fort Gorges in the distance. (Below, authors' collection.)

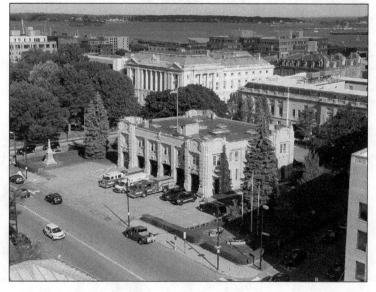

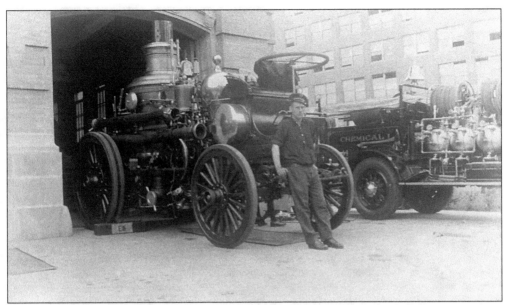

In 1925, after the opening of the new Central Fire Station, the photograph above was taken of a young firefighter, Thomas Murdock, who later became the first Training Division officer, standing in front of old Steam Engine Five with Chemical Company One parked beside it. In the present-day version, firefighter Tyler Nash leans against Engine Five, a 2011 Seagrave Marauder II, which is still stationed at Central. Bramhall's Rescue One, today's version of Chemical One, is positioned alongside Engine Five. The bay doors have changed in the 90-plus years between the photographs, but the exterior of Central still looks mostly the same. It is remarkable to note the difference in the size of the apparatus. (Below, authors' collection.)

In the photograph above from 1910, Chemical One is seen on the corner of Congress and Market Streets in front of Old Central. Rescue One replaced Chemical One on September 8, 1943. The present-day version shows Rescue One in the same spot with New Central in the background. Lt. Scott Krum and firefighter Dave Carter are standing, while firefighter Wendell Howard is in the driver's seat. Interestingly, Old Central was mostly razed into its own basement, sitting under the lawn between Market Street and New Central. Bricks from the old station were unearthed during the construction of the Portland Fallen Firefighters Memorial, seen to the right of Rescue One. (Below, authors' collection.)

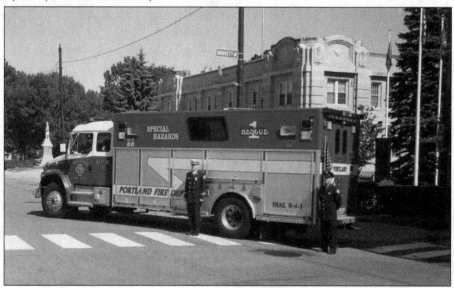

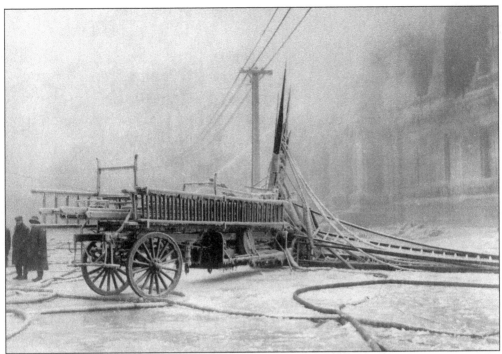

The ice-encrusted, broken aerial of Ladder Five is on the ground in front of the burned-out shell of city hall as the firefight continues on January 24, 1908. Chief Eldridge, in charge of the city hall fire, was grazed and knocked to the ground as the aerial fell. Ladder Five was the 1887 aerial that served many companies in its service life and was the only aerial in the department at the time. Below, the same view to the west down Congress Street shows the present-day city hall, whose design was heavily influenced by New York's city hall. In the backdrop, the Masonic Building, the Metropolitan Apartments, and first two high-rise buildings in the state of Maine, the Maine Bank & Trust and the Time and Temperature Buildings, are visible (Below, authors' collection.)

The engine house at 555 Congress Street was built around 1850 and had the original *Casco* Hand Engine One stationed here in 1854. It became home to the Portland Fire Department's first steam engine, *Machigonne*, in 1859, and the first motor pumper in 1917. Shortly after the photograph above was taken, the front was remodeled with a full third floor, visible below. Beyond that, very little has changed in over 115 years. Though the station closed in 1918, the former firehouse at 555 Congress Street is still recognizable today. It is now known as 555, a popular local restaurant. The large brick building on the corner is still very much the same as well. Ten Congress Square is visible in the distance. (Below, authors' collection.)

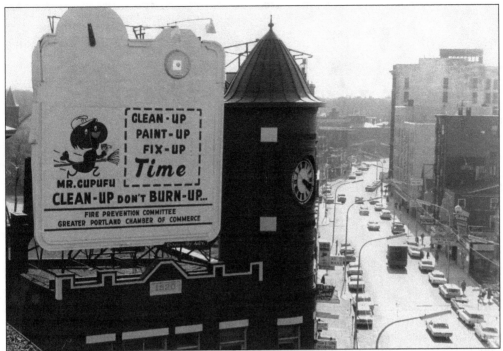

Above, in a photograph from the early 1960s of the Shwartz Building, a fire prevention billboard overlooks Congress Street. Many of these fire prevention posters and billboards were made by Portland's firefighters. The Shwartz Building is still standing today at the corner of Congress and High Streets. The present-day photograph was taken from the roof of the Portland Museum of Art, 7 Congress Square, at the corner of Free and High Streets. The Libby Building, where the original picture was taken, has been torn down, and its replacement has a slightly different elevation. The view down Congress Street looking west has not changed dramatically. The old Portland Public Library is barely visible to the far right. (Below, authors' collection.)

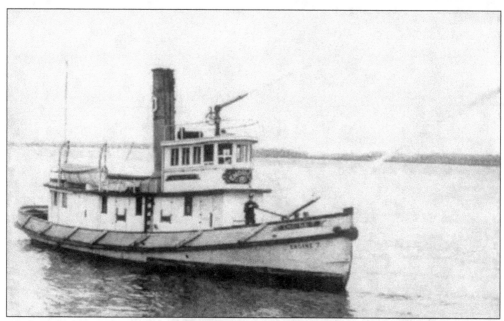

Above is the first official fireboat for the Portland Fire Department, Engine Seven, which organized in December 1894. The fireboat was originally a wooden ferryboat named *Chebeague* built in 1891. It was purchased in November 1894 and refitted with two Amoskeag steam pumps with two monitor nozzles. After renovations were made, pump trials were held in the harbor on February 19, 1895, and the boat was placed in service. Its quarters were located at the end of the Portland Pier, just off Commercial Street. The photograph below shows the current-day fireboat, the 2009 *City of Portland IV*, a 65-foot vessel that has 3,000-gallon-per-minute pumping capabilities. In 1948, Engine Seven moved to new quarters on the west side of the Maine State Pier, and it remains there today.

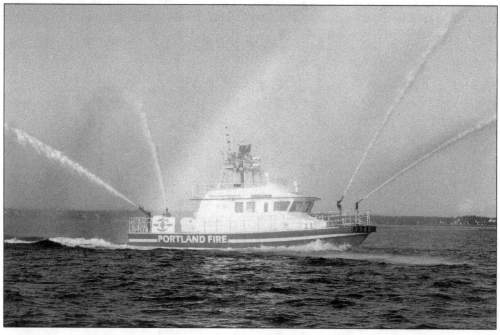

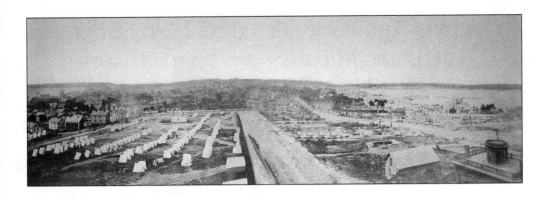

After the 1866 conflagration, a tent city is seen from the Portland Observatory on Munjoy Hill, looking down Congress Street. The destruction of the city by the fire is visible as far as the eye can see—a seemingly endless sea of free-standing chimneys and cellar holes. Over 1,500 buildings were destroyed, but it is said that the people of Portland began rebuilding their homes, businesses, the city, and their lives before the fires were completely extinguished. Below, 151 years later, the view shows how far the city has come, far beyond simply being rebuilt. The resilience of Portland's people after such a disaster underscores the motto *Resurgam*. The firefighters of Portland will forever serve these great people, answering the bell every hour of every day, as they have since March 29, 1768. (Below, authors' collection.)

DISCOVER THOUSANDS OF LOCAL HISTORY BOOKS FEATURING MILLIONS OF VINTAGE IMAGES

Arcadia Publishing, the leading local history publisher in the United States, is committed to making history accessible and meaningful through publishing books that celebrate and preserve the heritage of America's people and places.

Find more books like this at
www.arcadiapublishing.com

Search for your hometown history, your old stomping grounds, and even your favorite sports team.

Consistent with our mission to preserve history on a local level, this book was printed in South Carolina on American-made paper and manufactured entirely in the United States. Products carrying the accredited Forest Stewardship Council (FSC) label are printed on 100 percent FSC-certified paper.

MADE IN THE USA